STORIED PAST

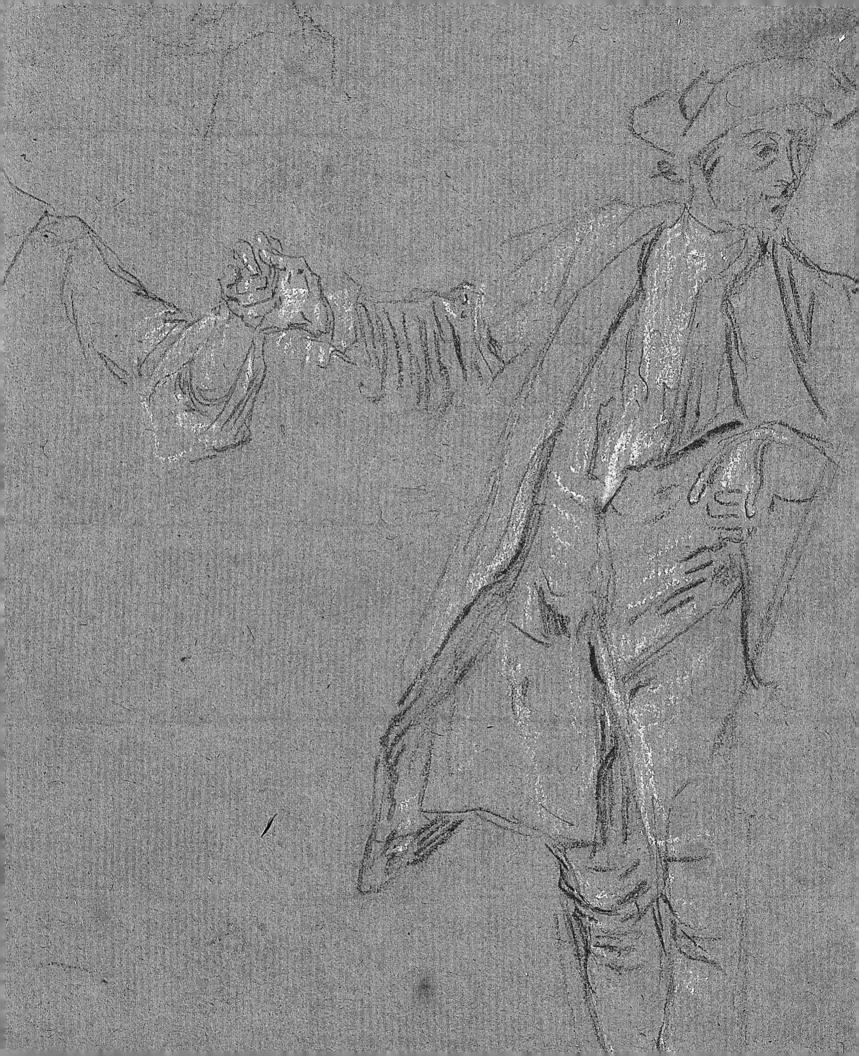

Storied Past

FOUR CENTURIES OF FRENCH DRAWINGS
FROM THE BLANTON MUSEUM OF ART

CHERYL K. SNAY

with essays by

Jonathan Bober *&* Kenneth M. Grant

THE BLANTON MUSEUM OF ART

in association with

HUDSON HILLS PRESS

MANCHESTER AND NEW YORK

Published on the occasion of an exhibition organized by the Blanton Museum of Art at The University of Texas at Austin. Support for curatorial travel is provided by the Still Water Foundation.

Exhibition Itinerary

The Frick Art & Historical Center, Pittsburgh
February 5–April 17, 2011

The Blanton Museum of Art, Austin
September 18–December 31, 2011

Iris & B. Gerald Cantor Center for Visual Arts at Stanford University
May 28–August 24, 2014

Published in the United States by Hudson Hills Press, LLC
P.O. Box 205, 3556 Main Street, Manchester, Vermont 05254

Distributed in the United States, its territories and possessions, and Canada by National Book Network, Inc.
Distributed outside of North America by Antique Collectors' Club, Ltd.

Publisher and Executive Director: Leslie Pell van Breen
Production Manager: David Skolkin
Design: Christopher Kuntze
Editor: Amanda Sparrow
Proofreader: Ted Gilley
Production Editor: Marisa Crumb
Indexer: Karla Knight
Printed and bound by Toppan Leefung
Founding Publisher: Paul Anbinder

Manufactured in China

LIBRARY OF CONGRESS CATALOGING-IN-PUBLICATION DATA
Blanton Museum of Art.
 Storied past : four centuries of French drawings from the Blanton Museum of Art / Cheryl K. Snay ; with essays by Jonathan Bober & Kenneth M. Grant.
 p. cm.
 Includes bibliographical references and index.
 ISBN 978-1-55595-356-0 hardcover
 ISBN 978-1-55595-365-2 softcover
 1. Drawing, French—Exhibitions. 2. Drawing—Texas—Austin—Exhibitions. 3. Blanton Museum of Art—Exhibitions.
I. Snay, Cheryl K. II. Bober, Jonathan. III. Grant, Kenneth (Kenneth Martin), 1958– IV. Title. V. Title: Four centuries of French drawings from the Blanton Museum of Art.
 NC246.B498 2011
 741.944'07476431—dc22 2010040899

Cover: François-Marius Granet, *Monks Entering a Cloister* (detail), 1802–1819. Pen and ink with brown and gray washes on ivory wove paper. The Blanton Museum of Art: Archer M. Huntington Museum Fund, 1987.18

Frontispiece: Nicholas Lancret, *Study of a Man* (detail), 1730s. Black and white chalks on gray laid paper. The Blanton Museum of Art: The Suida-Manning Collection, 357.1999.

CONTENTS

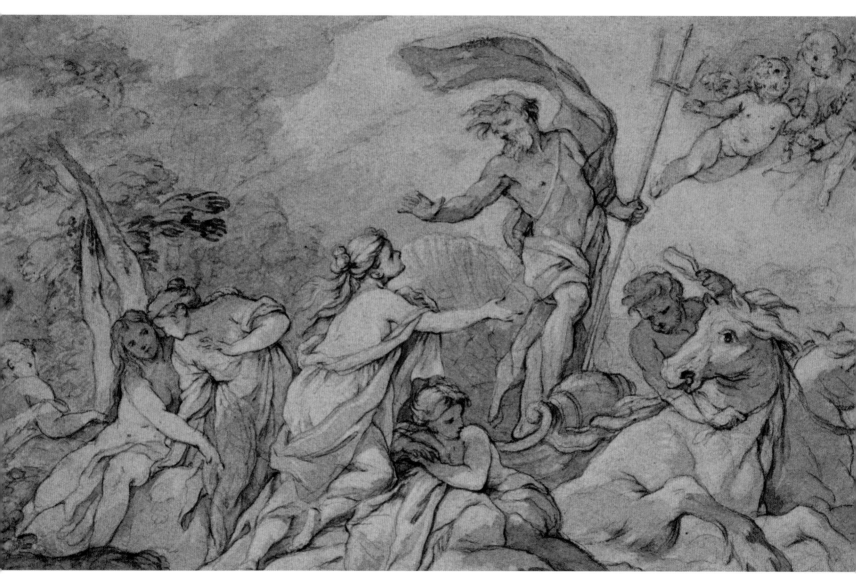

Charles-Joseph Natoire, *Neptune and Amphitritre* (detail), c. 1730s. Black chalk with brush and brown wash and white heightening on blue laid paper. The Blanton Museum of Art: The Suida-Manning Collection. 404.1999.

FOREWORD

THE HAND'S RELATIONSHIP to the eye, through the brain, is a well-studied aspect of neuroscience. What is less certain is the hand's relationship to that part of our human psyche or our more spiritual aspects that induce us to draw.

Drawing and the art of draftsmanship is depicting or expressing through linear manipulation. It is a creative practice that goes back to the cave, where those about to venture out to hunt, manufactured (*manu*—with hand; *facture*—to make) imagery of what was desired and envisioned.

Today, drawings by artists are often regarded as secondary, i.e., either preparatory to (or incomplete in this sense) or less valuable than the finished work of art. The Italian word *disegno* translates as both "design" and "drawing," and was once considered the primary, if not preliminary, form of art. It was seen as essential to visually conceptualizing how the final image would be structured. It was both skeleton and schema and served to consider and plan the organization of a figure on a field.

Drawing is not only a matter of line and composition, it also demonstrates the tracery and other mark-making handiwork on the surface of the paper, which like our skin is sensitive to the "touch" of the drawing implement. While quite a method both intimate and immediate, it also allows for erasure, at times, and multiple approaches to solving spatial issues on a page. Of all the methods of creating art, drawing is perhaps the most personal and closest to the germ of the artist's visual thinking.

Storied Past is an exhibition of fifty-eight sheets organized to highlight a selection of the French drawings from the collection of the Jack S. Blanton Museum of Art at The University of Texas at Austin, which has long valued and collected works on paper, a material that is something of an endangered species in today's "paperless" world of correspondence and business letters changing into the rapid flux of electronic messaging. Multitudes of artists continue to choose to work on paper in part because they understand and appreciate this sensual support for ink, charcoal, gouache, watercolor, and photosensitive coatings.

In this exhibition, one sees the variety of approaches to this way of inflecting imagery, including the use of paint to highlight or augment the use of pencil and crayon and the employment of colored paper. A drawing not only enables viewers to experience something

of the more initial strokes of visual creativity, it is also the most elemental and at times even notational. When examined closely, as advanced technology now enables us to do, we can begin to see not only the composition of a "picture" evolve, as if its very invention unfolds before our eyes—the artist's choices and decisions disclosed by microscopic examination—but also the composition of the fibers of the paper itself.

The entries for each of the drawings included in *Storied Past* address questioned attributions, discuss the known artists, and help us grasp the provenance of each. While the concrete and empirical data within these drawings may be inarguable, the aesthetic and other motivations leading to their creation are not always clear. This is an exhibition and publication that elucidates drawings executed by French artists over a period of four hundred years, signaling some of the changes in culture and art practice emanating from a particular region. The drawings themselves hover between the facts of the lines and modeling techniques and the mysteries of their most human dimensions.

Ned Rifkin
Director
The Blanton Museum of Art
The University of Texas at Austin
March 2010

ACKNOWLEDGMENTS

IT HAS BEEN a unique privilege to study the choice holdings of French drawings in the collection of The Blanton Museum of Art over the last four years. My deepest debt of gratitude is owed to Jonathan Bober, whose encouragement and support of this project has never wavered and whose advice on any number of issues has always been sound. Jonathan introduced me to many colleagues in the field on whose vast experience and keen eyes I have relied heavily. Especially notable among them are Perrin Stein, Margaret Grasselli, Mary Tavener Holmes, and Alvin J. Clark, all of whom I called upon frequently with questions and problems. Others—including Jean-François Méjanès, Henri Zerner, and Suzanne McCullough, to name just a few—provided valuable opinions and guidance. I am equally indebted to Kenneth Grant, conservator at the Harry Ransom Center at The University of Texas at Austin, for his estimable contribution to the catalogue and his insights into the material and techniques on display in the Blanton's drawings. I have always found working with conservators to be among the most rewarding of assignments, and this was no exception.

Exhibitions and catalogues of this nature and scope require the commitment of the entire staff, some of whom have moved on in their careers since the project began. I would like to thank print-room manager Catherine Zinser and preparators Tim Reilly, Jamie Berlant-Levine, and Chris Reno for their assistance and expertise. Additionally, registrars Sue Ellen Jeffers and Meredith Sutton offered significant help in many collection-management database and logistical issues. To Rick Hall—The Blanton's good-humored, patient, and attentive photographer—I extend my sincerest compliments on his technical skill, prowess, and infinite cheer. Graduate-student interns played no small role in this project over the years. I must thank Alexia Rostow, Joelle Lardi, Laura Valeri, and Aleyna Langlais. Tatiana Segura, too, provided valuable translation services.

The co-presenters of the exhibition, directors Thomas Seligman at the Cantor Arts Center and William Bodine at the Frick Art & Historical Center, deserve our deepest appreciation for their early and steadfast trust in a project that was long in the making. I had the pleasure of renewing old friendships and meeting new colleagues at these museums. Bernard Barryte, of Stanford University, and I have worked on several projects in the past, and I have always gained much from our collaborations. Exhibition coordinators Sara Kabot at Stanford and Sarah Hall at the Frick Art & Historical Center in Pittsburgh have made this process both easy

and enjoyable. I am particularly grateful to the staff at Hudson Hills Press—Leslie Pell van Breen, Marisa Crumb, and Melanie Finigan—for their care and professionalism in managing every minute detail related to the publication of the catalogue.

Without the invaluable benefaction of Julia Wilkinson and her belief in the importance of the Suida-Manning Collection, her leadership in its acquisition, and, through the Still Water Foundation, the gracious support of travel funds to conduct research, none of this would have been possible. Equally notable was the understanding of former president Larry Faulkner, who went to extraordinary lengths to bring the collection to Austin. They have been longtime and generous friends of the university, the museum, and the curators. *Storied Past* is only the latest manifestation of their faith in the potential of the collection to stimulate research, increase knowledge, and enhance the museum's and the university's standing among its peers.

Finally, I would be remiss if I did not acknowledge the endless balance and consideration of The Blanton's director, Ned Rifkin, and deputy director for art and programs, Annette Carlozzi, who demonstrated confidence in both the collection and the staff in an era fraught with fiscal crises and budgetary concerns.

There are many more people who contributed to this endeavor than I can possibly list here. To them, I am most appreciative for their counsel, their help, and their forbearance.

Cheryl K. Snay
September 2010

STORIED PAST

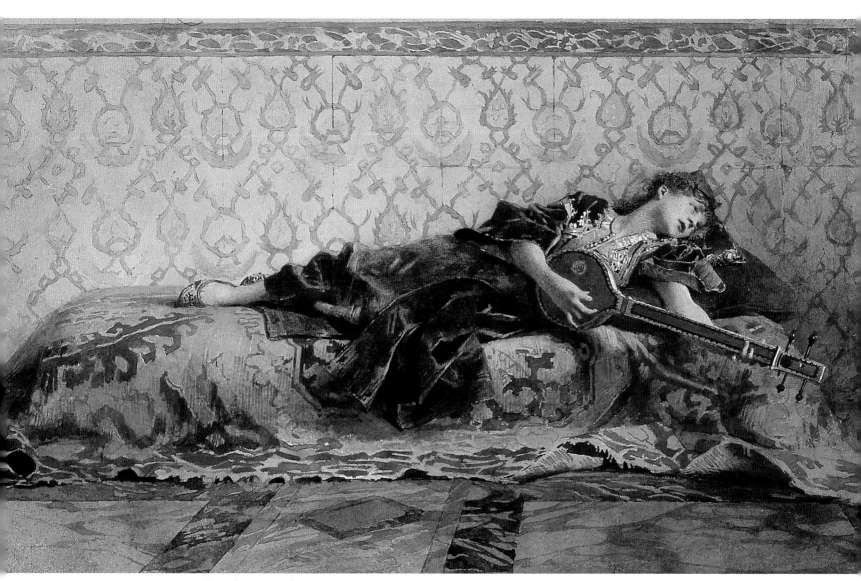

Alexandre-Louis Leloir, *Moroccan Girl Playing a Stringed Instrument* (detail), 1875. Watercolor, gouache, and graphite on ivory wove paper. The Blanton Museum of Art: Gift of the Wunsch Foundation, Inc. 1983.133.

Storied Past

CHERYL K. SNAY

THE FRENCH DRAWINGS in The Blanton Museum of Art tell many stories. Most simply, they tell the stories of the historical, Biblical, and mythological heroes that were favored at the time by the patrons and consumers of art, and these narratives are addressed in the individual catalogue entries for the works included in the exhibition. During the period under review, 1500 to 1900, art—and especially drawing—served an educational and salutary purpose. Art was meant to be morally uplifting through both its subject matter and formal properties. The transformative experience—the attainment of higher cognition and consciousness—occurred not merely from understanding the lessons of history, religion, and mythology as they were described pictorially, but equally from an analysis of the physical object and its mastery of artistic conventions.

Fundamental to making art was drawing. It is worth remarking on the traditional primary relationship of drawing to painting, sculpture, and architecture as well as its relocation in the late twentieth century, dramatically manifested by Robert Rauschenberg's *Erased de Kooning* (1953, San Francisco Museum of Modern Art). Rauschenberg's act of iconoclasm was not meant to destroy de Kooning, an artist whom he admired and who willingly participated in the endeavor by providing him with the image to be obliterated, but rather it was a way of working.[1] Sixty years later, some modern and contemporary drawings have achieved a kind of autonomy from other mediums; but old master and, to a lesser extent, nineteenth-century drawings that partake of the former system are often relegated to a lower rank, their relevance to cognition diminished. Considered by some to be "unfinished paintings," drawings are sometimes dismissed as uninteresting or esoteric. Modernism, with its emphasis on "progress" and stylistic evolution, did value drawings as markers of the creative process, but they are much more than that.[2] Drawings provide insight into a manner of thinking by a society no longer extant and accessible only through analysis of its material culture. Drawings—both their execution and appreciation—make excellent primary sources for research because they were regarded as a means of ordering reality.[3] At the Académie de Rouen in 1777, Charles-Nicolas Cochin (1717–1790) argued for the primacy of man and the necessity of drawing as a mechanism for articulating that concept:

I am not afraid at all to advance a proposition which at first seems to be a paradox, but the truth of which is proved by the facts; it is that all degrees of superiority, *not only in the arts but even in all the professions which depend on the arts*, is relative to the degree of superiority that the artist has acquired in the art of drawing the human figure.[4] [emphasis added]

Charles-Antoine Jombert (1712–1784) underscored a fundamental principle of the Académie Royale de Peinture et de Sculpture since its inception in 1648 when he wrote, "Drawing is the soul of painting."[5] Throughout the political and social revolutions of the late eighteenth and nineteenth centuries that resulted in an ongoing reformation of the academy, its methods, and beliefs (the primacy of copying; that is, whether "true" artists were born with an innate ability or could be taught), faith in drawing never wavered: "To learn to draw is to learn to *see well*, to see exactly the relationship of things and of their constituent parts"[6] [emphasis in original]. We would do well to remember that students at the École des Beaux-Arts learned to draw, and they studied anatomy, history, and math in order to do so; painting and sculpture were taught only in private studios. In postrevolutionary France, drawing was no longer the purview exclusively of professionals and wealthy amateurs; it became an integral part of the state-mandated curriculum in public schools, a powerful tool in democratizing society, afforded to increasingly larger segments of the working class and girls. Provincial drawing schools proliferated in France.[7] Drawing manuals directed to the independent learner were published by the score, translated, and produced in multiple editions.[8] This idea was not unique to France and was, in fact, based on earlier Italian models. The role of the French in this paradigm was to centralize and institutionalize the principle that "drawing is the soul of painting" and to export it to other countries through the French Academy—its pedagogy, administrative structures, exhibitions, competitions, and prizes—which became the arbiter of taste in the West. French drawings warrant our attention because they are evidence of a discipline whose impact on Western culture is little understood.

Storied Past also examines the history of these drawings as objects.[9] In conventional art historical parlance, this can be construed as provenance (the history of ownership) and connoisseurship (from the French verb *connaître*, meaning "to know": a state of knowing or an ability to discriminate). Implicit in the history of collecting and connoisseurship is the accrual of meaning to an artwork through its subsequent collectors and scholars. This is not to suggest that any and all interpretations are valid or that later interpretations necessarily supersede earlier ones (see cat. 12); rather, provenance and connoisseurship illuminate the processes by which meaning is constructed—not revealed, because meaning is not inherent to an object—as well as which of these processes are more fruitful than others.

Comprised largely of works from the Suida-Manning Collection formed in the first half of the twentieth century, the Blanton's holdings of French drawings provide an opportunity to review the history of collecting these images. William Suida (1877–1959), his daughter Bertina (1922–1992), and her husband Robert Manning (1924–1996) spent their lives in art

historical pursuits, and their activities are the subject of Jonathan Bober's essay chronicling the formation of the Blanton's collection. In an age before the Internet, online searchable databases, digital photography, e-mail, Google books, and interlibrary loans, that endeavor was not an easy one. It meant that a scholar or connoisseur had to be well traveled, well read, well funded, and well connected.

Drawings as collectibles have long been the concern of a relatively small and elite circle because acquiring them is risky and labor intensive. In the seventeenth century, collectors of paintings largely distrusted drawings because it was (and continues to be) difficult to distinguish the work of a master from that of a student whose legitimate occupation was to create a copy. There are fewer records concerning drawings, and some of them are ambiguous at best. Sales catalogues are notoriously bereft of descriptions, titles, sizes, or any information that could be used to positively identify a sheet; often many individual and unrelated works are combined in a single lot. For the purposes of building a collection, finished drawings—if any at all—were preferred because they more closely approached a painting.

The collector Pierre Crozat (1661–1740), who made his fortune as a banker, owned approximately 19,200 drawings kept in 202 portfolios. It is a telling statistic that seventy percent of them were Italian; eighteen percent were from northern schools; and only twelve percent were French. Crozat is characterized as having "great reservations about contemporary artists,"[10] yet his first purchases were drawings by Raymond Lafage, who in 1683 passed through Toulouse where Crozat, then only eighteen years old, lived. Pierre-Jean Mariette (1694–1774), a well-respected dealer, came from a family of engravers. He trained for his profession by visiting collections around Europe, studying the art market in Amsterdam, and cataloguing the art collection of the Prince of Savoy in Vienna. Upon Crozat's death, Mariette was asked to compile the catalogue of his extensive collection for its subsequent sale. He later produced a similar catalogue of the thousands of prints held by Jean V, king of Portugal, still consulted today by scholars and collectors.[11] Mariette's connections served him well: in addition to buying and selling prints and drawings for a living, he formed a collection of his own, part of which became the subject of an exhibition at the Musée du Louvre in 1967.[12] Artists, too, collected drawings, but largely for practical rather than philosophical reasons. For example, François Boucher owned drawings by Jean Jouvenet and copied them. As director of the Académie de France in Rome, Charles-Joseph Natoire acquired a sizable collection of works by masters who preceded him and by some of his contemporaries.[13] It is easy to imagine that Natoire shared these drawings with his students to impart lessons about selecting good models, technique, proportion, scale, and composition, among other things. These images easily could have inspired new work, either his own or that of his students. In the nineteenth century, Philippe de Chennevières, the Director of Fine Arts from 1873 until 1879, amassed an impressive collection of drawings. Interestingly, he and another historian published the collected writings of Mariette still in manuscript form, in six volumes, between 1851 and 1860.[14] Chennevières organized a public exhibition of old master drawings at the École des

Beaux-Arts that was on view from May to June 1879. He explicitly stated in the catalogue's introduction his desire to expose the public—who otherwise would not have access to the *cabinet des dessins* at the Louvre—to the didactic properties of drawings.[15] Although he focused on Italian masters in charting artistic achievement through the sixteenth and seventeenth centuries, he shifted to French artists in the eighteenth. In his view, drawings by Chardin, Greuze, Fragonard, and Jeaurat (see cat. 28 for Chennevières's stamp) were important because they provided the most sure, most intimate, most representative, most authentic documents of the history of their time, even *more irrefutable than written documents*.[16]

To bring this summary of notable collectors of drawings into the twentieth century, it is worth mentioning a contemporary of William Suida, Fritz Lugt (1884–1970). A collector and connoisseur, Lugt is best known for publishing standard reference books: *Les Marques de collections de dessins et d'estampes* (Amsterdam, 1921); its *Supplément* (The Hague, 1956), now available online; and the three-volume *Répertoire des catalogues de ventes publiques* (The Hague, 1938–1964). His own collection of French drawings has become the subject of a recent exhibition and catalogue.[17] He advocated that a beautiful drawing by a minor artist is preferable to a bad drawing by a great artist. Going further, he said, "Something 'resonates' in a modest collection that is infinitely preferable to the showy chilliness of large ones."[18] His sentiment serves admirably to justify the present project.

The idiosyncrasy of the Suida-Manning Collection, with its emphasis on "Italianate" French drawings, begs the question of the relationship between French artists and Italian art. When feasible, catalogue entries include biographical information about the artists that sheds light on this issue. Did the artist go to Italy and "convert" to its artistic traditions to such an extent that his work was mistaken for that of his Italian contemporaries, as was the case for Étienne Parrocel (cat. 27)? Did he travel there and reject its traditions or choose unconventional artists or monuments to study? What was the impact of those decisions on his art? Like Jean de Saint-Igny, did he remain in France and know of Italy only through reproductions, literary descriptions, and word of mouth (cat. 8)? Or, like Théodore Rousseau, was he denied the opportunity to go to Italy, becoming more nationalistic as a result and further eroding the classical model embraced by the academy (cat. 46)? There is no clear trajectory traced in our study and to try to establish one would require a far larger sample than the one presented here. Still, such projects are useful in identifying topics worthy of further examination.

Another facet of the social life of drawings is present in technical observations. In his essay, paper conservator Kenneth M. Grant offers different insights into the origin, function, and nature of drawings. His examination of joined, colored, and "extinct" papers raises questions about studio practices and artists' intentions. Grant approaches the material from the point of view of a scientist—clinically, analytically, dispassionately, with no preconceived notions of what he should be looking for or what he may find. He makes no value judgments about quality or virtue based on long-held opinions of an artist's reputation as a master. The drawing by Adolphe Appian on Gillot paper is just as interesting—perhaps more so—as the rare early sheet by Boucher because it is more informative about technological developments

and consumer culture at the turn of the twentieth century than its eighteenth-century predecessor is about its own. Grant's case studies are not meant to be exhaustive, but rather to spur further research.

The motives for undertaking a project such as this one are many and varied, and I have tried to outline the most relevant incentives here. Underlying all of them, however, is an effort to make the methodologies of art history more transparent. Simply put: What do we know? How do we know it? Who decides what is worth knowing? What I hope will be apparent to visitors to the exhibition and readers of this catalogue is that meaning is never static or complete. Often what we learn about an object tells us more about who made the discovery and less about the work itself. This can be the case for any material—Italian paintings, German sculpture, medieval manuscripts. But the Suida-Manning Collection is pertinent precisely because its singularity calls into question conventional narratives of French dawings.

NOTES

1. Vincent Katz, *Tate, etc.* 8 (Autumn 2006): 38–41. See also, "Coda: Canons and Contemporaneity" in *Partisan Canons*, ed. Anna Brzyski, 309–326 (Durham, NC: 2007).

2. "There is a certain quality about original drawing which you cannot get in a woodcut, and the best part of the genius of many men is only expressible in original work, whether with pen or ink—pencil or colour." John Ruskin in his lecture, "The Political Economy of Art," delivered in Manchester in 1857 and edited in 1880. E.T. Cook and Alexander Wedderburn, eds., *The Works of John Ruskin* (London, 1903–1912); vol. 16, 42.

3. James Henry Rubin, *Eighteenth-Century French Life Drawing* (Princeton, 1977), 35.

4. "Je ne crains point d'avancer une proposition qui d'abord semble un paradoxe, mais dont la vérité est prouvée par les faits; c'est que tout degré de supériorité, non seulement dans les arts, mais encore dans toutes les professions qui en dépendent, est relatif au degré de supériorité que l'artiste a acquis dans l'art de dessiner la figure humaine," as quoted in Renaud d'Enfert, *L'Enseignement du dessin en France 1750–1850* (Paris, 2003), 56.

5. Charles-Antoine Jombert, *Méthode pour apprendre le dessin* (repr., Geneva, 1973). Jombert's manual, directed at drawing instructors, first appeared in Paris in 1740 and was reissued in a new edition in 1755.

6. Edouard Cuyer, *Le Dessin et la peinture* (Paris, 1892), 201.

7. Renaud d'Enfert, *L'Enseignement du dessin en France 1750–1850* (Paris, 2003), 19.

8. Charles Blanc, *La Grammaire des arts du dessin* (Paris, 1867).

9. Here, I am informed by Arjun Appadurai, *The Social Life of Things: Commodities in Cultural Perspective* (Cambridge, 1986).

10. Cordelia Hattori, "The Drawings Collection of Pierre Crozat," in *Collecting Prints and Drawings in Europe circa 1500–1750* (London, 2003), 175.

11. Pierre-Jean Mariette, *Catalogues de la collection d'estampes de Jean V, roi de Portugal*, originally compiled in the late 1720s with a new edition co-published by the Fundacao Calouste Gulbenkian in Lisbon and the Bibliothèque nationale de France in Paris in 2003.

12. *Le Cabinet d'un grand amateur, P.-J. Mariette, 1694–1774* (Paris, 1967).

13. Georges Brunel, "Charles-Joseph Natoire Collectionneur," in *Charles-Joseph Natoire* (Nantes, 1977), 35. Citing a letter from Vien to d'Angiviller, Brunel explains that much of what was in Natoire's collection is unknown to us as it was sold by his brother privately before the public auctions were held. "Une grande partie des desseins fait par M. Natoire et autres maîtres ont été également vendus."

14. Pierre-Jean Mariette, *Abecedario*, with annotations by Philippe de Chennevières and A. de Montaiglon, (Paris, 1851–1860).

15. Philippe de Chennevières, *Les Dessins de maîtres anciens* (Paris, 1880), 8.

16. Ibid., 115.

17. The Frick Collection mounted this show last year. *Watteau to Degas: French Drawings from the Fritz Lugt Collection* (New York, 2009).

18. Ibid., 16–17.

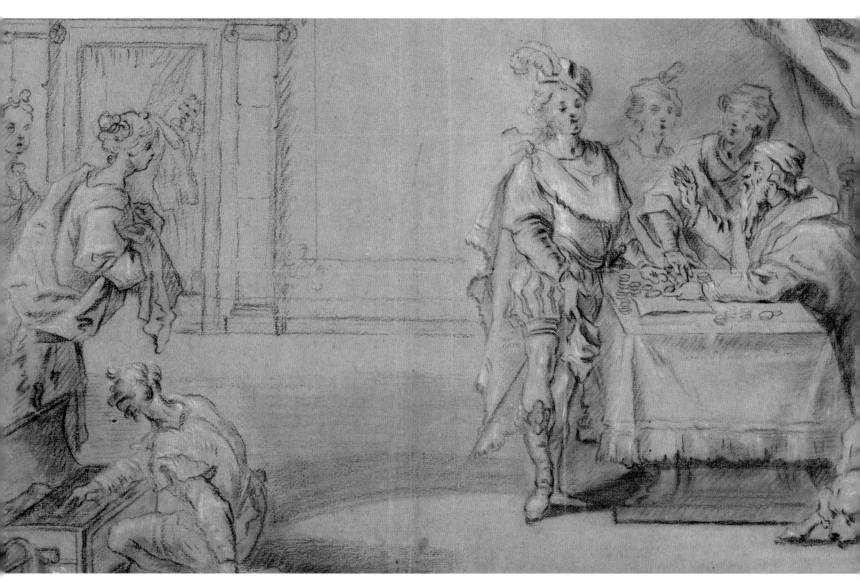

Circle of Claude Vignon, *A Pawnbroker's Shop* (detail), late 17th century. Black and white chalk on buff laid paper.
The Blanton Museum of Art: The Suida-Manning Collection, 592.1999.

French Drawings at The Blanton

A Short History

JONATHAN BOBER

FRENCH DRAWINGS ARE the least known of the six hundred European sheets in The Blanton Museum of Art. Certainly a few, like François Boucher's early *Mucius Scaevola Putting His Hand in the Fire* (cat. 31) have been regularly exhibited and published, and others have become familiar to the university and visitors. Most of the drawings, however, are virtually unknown. They have been overwhelmed in number and significance by the museum's three hundred and fifty Italian drawings, largely from the Suida-Manning Collection. The importance of this group—at least equal to that of the collection's paintings—was recognized long before its acquisition by the university in 1998, and since then it has only been underscored by systematic presentation and substantial discussion.[1] The French sheets have even been overshadowed by the museum's three dozen central European drawings, which are marked by their quality, coherence as a group—nearly all were acquired by William Suida in Austria at the beginning of the twentieth century—and reputation.[2] But the neglect of the museum's French drawings is not just relative. As a unit, their quality may seem compromised by the number of modest works, principally of the nineteenth century. At the same time, many of the finest and most interesting drawings have resisted even basic identification, the result of both insufficient attention and the lack of knowledge, at least of seventeenth-century French drawings. Finally, while The Blanton's French drawings offer a number of what prove to be important concentrations in style and character, some basic chapters and many protagonists in the brilliant history of French draftsmanship are missing.

The present exhibition and catalogue are a valuable corrective. Limited to works created before 1900, and especially selective among those of the preceding century, the project is predicated on an assessment of quality and interest beyond simple nationality. These fifty-four drawings represent slightly less than half of the museum's pertinent French drawings. They are addressed systematically and rigorously, not only with expected reference to the rapidly growing literature on French drawings,[3] but integrating opinion of leading scholars in the field based upon firsthand examination and equally expert technical analysis. The project

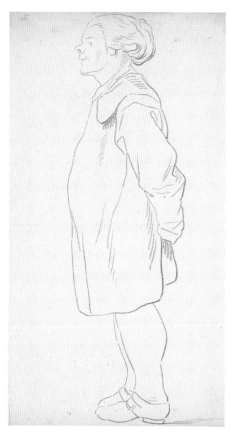

Fig. 1. Copy after Carle Vernet [?], *Smiling valet de chambre*, red chalk. The Blanton Museum of Art, gift of Thomas Cranfill, 1980.79

brings to light some interesting examples by major artists, like Jacques Callot and Jean-Honoré Fragonard (cats. 37 and 38), but more often major examples by lesser-known artists, such as Jean de Saint-Igny (cat. 8), François Verdier (cats. 17 and 18), and François-Marius Granet (cat. 42). Particularly important is the larger number of drawings of high quality and distinct personality but problematic identification. It is both the nature of The Blanton's holdings and the accuracy of the project that so many sheets are here "attributed" or assigned to a "circle." Some of these—like the drawings related to Guy François (cat. 3), Claude Vignon (cat. 6), and Raymond Lafage (cats. 19, 20, and 41)—represent challenges to the field. The selection, the individual entries, and their sequence end up suggesting a surprisingly consistent whole. The seventeenth century generally predominates over the eighteenth, the Italianate tradition over the indigenous, and the mainstream academic over the more progressive. More than simply making The Blanton's holdings better known, *Storied Past* implies an unconventional, at times eccentric, and often provocative counterpoint to the standard history of French draftsmanship.

The collecting of French drawings at The Blanton began slowly and modestly. The University Art Museum, as it was first called, was created in 1963. Apart from a handful of prints, there were no old master or early modern European works of any kind in the major private collections that laid the foundation of the museum's own, or among the individual acquisitions made during the institution's first fifteen years. The first material of the kind arrived in the late 1970s as part of large collections that were roughly divided between the museum and the Harry Ransom Humanities Research Center. Alvin Romansky (1907–1994), an attorney and patron of the arts in Houston, was an enthusiastic collector of nineteenth- and early-twentieth-century European graphics with an emphasis on political subjects and social commentary. Starting in 1968, his donations to the museum brought nearly nine hundred works (and another seven hundred and twenty-five to the Ransom Center). Gifts from 1977 to 1978 included fifty French drawings, mostly studies for illustration, advertisements, or costume. Those of aesthetic distinction—the obscure Belloguet (cat. 50), Edouard de Beaumont (cat. 48), Théophile-Alexandre Steinlen (cat. 53), and Henri Rivière (cat. 54)—appear in the present exhibition. A few more—by minor figures such as Edmond Geffroy (1982.264), Julien Dupré (1982.378), and Raymond Gallier (1982.406)—stand as examples of late academic practice as it carried into commercial illustration. Most are anonymous. Thomas Cranfill (1913–1995), a professor of English at the university, was an avid collector of modern Mexican art who owned various other works, including Japanese *ukiyo-e* and modern European prints. Between 1977 and 1984, his donations brought four hundred and thirty-nine objects to the museum (and a similar number to the Ransom Center). Among these donations was a series of ten red-chalk caricatures once optimistically ascribed to Carle Vernet (1980.78–87; fig. 1); they are, in fact copies roughly in his manner. Their quality aside, these works were the collection's first old master French drawings.

The next stage in The Blanton's acquisition of French drawings was opposite in kind. In 1978 to 1979, the professional staff was enlarged, the scope of the collections expanded, and a

large percentage of the income from the single operating endowment applied to the purchase of artworks. Renamed in honor of the donor who in 1927 had given the university land and mineral rights to establish an art museum, the Archer M. Huntington Art Gallery would spend more on acquisitions than any other university museum in the country for nearly a decade. Principal among the purchases were groups of antiquities, including several very fine Greek vases and examples of Roman sculpture; a score of old master paintings, including a group of northern mannerist works and a few Italian paintings; and the museum's first estimable old master drawings.[4] These drawings were bought for their correspondence to the history of art as taught in the undergraduate classroom (although they did not include any Italian work) as well as their assumed importance. Early on there were the ambitious acquisitions of a pair of delicate designs from the school of Fontainebleau and, beginning the representation of the eighteenth century, three canonical French drawings: the wonderfully fresh François Le Moyne (cat. 23), the landscape attributed at the time to Antoine Watteau (cat. 22), and the late Boucher (cat. 32). At the end of this period, the drawing formerly attributed to Augustin de Saint-Aubin (cat. 44) would add an example of another eighteenth-century type: the festive interior scene. At the same time, the purchase of three fine drawings—the Granet, the Henri-Joseph Hesse (cat. 43), and the Jacque *fils* (cat. 52)—along with the donation of the Alexandre-Louis Leloir (cat. 49) and Jean-Louis Forain (cat. 51) leavened the representation of nineteenth-century French draftsmanship. All of these works are present in this exhibition, and, with a couple of qualifications, they remain among the museum's most distinguished French sheets.

The museum's financial situation changed significantly in the wake of the economic collapse of October 1987. For the next twelve years, there would be no budget for acquiring prints and drawings. In its place there grew private support, but it was dedicated overwhelmingly to the development of the print collection. (In this context, it is worth noting that French prints of the seventeenth and eighteenth century became an area of special focus and considerable depth.[5]) The only earlier French drawing actually acquired during this period was a figure study probably from the Académie at Lyons (1992.290; fig. 2)—a late example of a type not previously represented.

In the meantime, the museum had been presented a very different kind of opportunity. With approximately two hundred and sixty paintings and more than four hundred drawings, the Suida-Manning Collection was the largest collection of old master works still in private hands in the United States and one of the most extensive of baroque art anywhere.[6] Begun around the turn of the century by William Suida (1877–1959), the protean and pioneering Austrian art historian of northern Italian painting, the collection resembled those of other great scholars of the period, such as Bernard Berenson and Roberto Longhi, in its expression of highly specialized knowledge and reflection of extraordinary sensibility. Exceptional among such collections, Suida's own saw a second generation in the more sustained and systematic efforts of his daughter, Bertina (1922–1992), and son-in-law, Robert Manning (1924–1996), themselves art historians. The Suida-Manning Collection had become not only

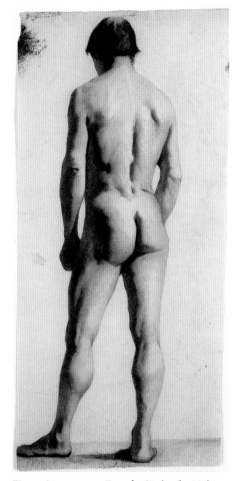

Fig. 2. Anonymous French, *Study of a Male Nude Seen from Behind*, mid nineteenth-century. Black chalk. Blanton Museum of Art, purchase through the generosity of the Friends of the Archer M. Huntington Art Gallery, 1992.290

large but concentrated and deep like very few American collections, private or public. While it included numerous examples by canonical Italian figures—including Veronese, Rubens, and Tiepolo—it featured outstanding works by less familiar artists, multiple works by other masters, from Luca Cambiaso to Sebastiano Ricci, and the representation of entire schools, above all the Genoese, which was unique outside of the Ligurian capital. Moreover, because of the Mannings' zeal in promoting their interests and generosity in sharing their collection—with scholars who visited their home as well as with the public through frequent exhibitions—it had become very well known. In late 1998, through a complex gift-purchase agreement, the university acquired the entire Suida-Manning Collection.

French works are an important part of the Suida-Manning Collection. Thirty paintings and forty drawings, they represent the second largest national group in each medium. Chronologically all but two of the paintings—portraits by Nicolas de Largillière (359.1999) and Louis Tocqué (558.1999)—and the majority of drawings belong to the seventeenth century. In terms of style, the collection favors works closely related to Italian tradition rather than the more strictly French: paintings by artists active in early-seventeenth-century Rome and drawings by those who spent extended periods in Italy or, more broadly, those who embraced an academic classicism. The emphasis, in other words, runs against what remains the general preference in scholarship, and in the market, for realist currents in the seventeenth century and progressive ones in the eighteenth. Like Italian works in the collection, the French include some of individual significance but feature choice pieces by less familiar figures and often in multiple examples, with Louis Licherie, François Verdier, again Lafage, and Charles-Joseph Natoire among the draftsmen. In basic characteristics and in principle, the French works are the exact counterpart of the Suida-Manning Collection's widely recognized Italian ones. Though on a considerably smaller scale, their addition similarly transformed that part of the museum's collection, making it one of the major repositories of the French baroque in this country.[7]

Typical of the Suida-Manning Collection, little is known about the history of its initial acquisitions. Notwithstanding the Mannings' efforts to share their interests and to make the collection accessible, the family was uninterested in documenting provenance or the circumstances of acquisition. Rather, the collectors seem to have preferred that these sources remain vague, that the collection appear a familiar achievement to the public and even to scholars, that its consistency remain fluid—more fluid than has been generally recognized.[8] The considerable archival materials that came to The Blanton with the Suida-Manning Collection appear to contain scant evidence and only a handful of true receipts for works of art.[9] While William Suida was alive and then later into the 1960s, objects from the collection were generally credited to one name (Suida) or the other (Manning) when they were loaned to exhibitions or published; later, the names were joined in a single, hyphenated entity. Since very few of the French drawings were brought to light, even such ambiguous information is largely absent. It is thus especially difficult to reconstruct their sources and sequence, and impossible to know priorities or any pattern in how they were assembled.

On the other hand, much can be gathered about the larger role and meaning of the French works in the Suida-Manning Collection. They are the one significant component of the collection that was unrelated to Suida's scholarship, therefore predictably absent from his corollary collecting. The most important document for distinguishing the works acquired by Suida alone, a fire insurance policy of 1948, lists forty-three paintings and a "group of 100 Old Master drawings," but only one French work, a landscape sketch by Renoir.[10] Instead, French art was the special interest of Robert Manning. This concern had several bases. It echoed Suida's pursuits beyond the art historical canon and indifference to the tastes of conventional collectors, in turn increasing both the chances of affordability and the opportunities for discovery. Manning's embrace of earlier French art was also the first instance of what would become typical after Suida's death: acquisition according to aesthetic preference and only then intellectual framing and systematic inquiry—the opposite of the usual sequence in scholarly collecting. Most of all, the concern with French art should be recognized as an assertion of aesthetic independence from his father-in-law, his wife's dedication to her father's scholarly interests, and the two Mannings' initial adherence to his areas of collecting.[11] It is telling that, right after Suida's collaboration with his daughter on the monumental study of Luca Cambiaso,[12] Robert Manning should have acquired the collection's first paintings by Simon Vouet (601.1999; fig. 3)[13] and Vignon (593.1999), and contributed an article on Vouet to the *festschrift* for his father-in-law.[14] Inevitably, seventeenth-century French painting was the subject of one of the remarkable series of exhibitions that Manning organized for the small gallery at Finch College, which he directed from 1961 until the college closed in 1971.[15] The very personal nature of his relationship to the culture is made clear by a statement in the slender catalogue's introduction:

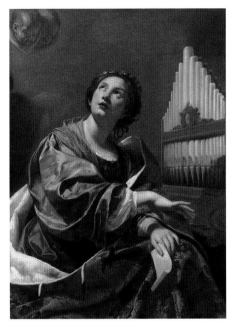

Fig. 3. Simon Vouet, *St. Cecilia*, c. 1626. Oil on canvas. The Blanton Museum of Art, The Suida-Manning Collection, 601.1999

> *The artistic heritage of France during that splendid century is indeed luminous and worthy of being once again conjured up before the eyes of the beholder of a century which can only profit spiritually from the illumination of that opulent age.*

Of course, the full expression of Robert Manning's passion is ultimately to be found in the collection itself. More than any other person or circumstance, he is responsible for the fact and character of the present endeavor.

NOTES

1. See J. Bober, *I grandi disegni italiani del Blanton Museum of Art del Università del Texas* (Milan, 2001) as well as N. Turner, "Breve storia del collezionismo di Old Master Drawings in Inghilterra e negli Stati Uniti," in *Disegno e disegni: Per un rilevamento delle collezioni dei disegni italiani*, ed. A. Forlani Tempesti and S. Prosperi Valenti Rodinò (Florence, 2003), 150, where The Blanton's holdings are listed among the "principal public collections of Italian drawings in the United States"—apart from the Chrysler Museum at Norfolk, the only one in the South or Southwest.

2. A total of twelve drawings were included in the exhibitions *Drawings from the Holy Roman Empire: A Selection from North American Collections, 1540–1680* and its sequel *Central European Drawings, 1680–1800: A Selection from American Collections*. Their catalogues, by T. DaCosta Kaufmann (Princeton, 1982 and 1989), remain the most thorough and reliable presentations of the subject in English.

3. While scholarly attention to the drawings of Nicolas Poussin and the most celebrated French artists of the eighteenth century—Antoine Watteau, Boucher, Jean-Honoré Fragonard, Jean-Baptiste Greuze—is undiminished, the series of *Cahiers du dessin français*, published by the Galerie du Bayser, Paris, has since 1985 added fourteen monographic studies on the drawings of less prominent figures. Meanwhile, numerous public as well as private collections of French drawings have been the subject of exhaustive study and equally comprehensive presentation. The most recent volumes of this kind include: D. Cordellier, P. Rosenberg and P. Märker, *Dessins francais du musee de Darmstadt: XVI, XVII, XVIII siecles* (Montreuil and Darmstadt, 2008); C. B. Bailey, S. G. Galassi, and M. van Berge-Gerbaud, *Watteau to Degas: French Drawings from the Frits Lugt Collection* (New York, 2009); F. Lanoë, *Trois maîtres du dessin: Philippe de Champaigne (1602–1674), Jean-Baptiste de Champaigne (1631–1681), Nicolas de Plattemontagne (1631–1706)* (Paris, 2009); and M. Morgan Grasselli, *Renaissance to Revolution: French Drawings from the National Gallery of Art, 1500-1800* (Washington, DC, 2009).

4. The very first was a characteristic study of seaside dunes from a sketchbook by Esaias van de Velde (1980.55). In 1982, there followed eight more old master drawings, ranging from an early Netherlandish pen study by Aert Ortkens (1982.699) to the supposed Watteau (1982.725) and Boucher (1982.724) mentioned here, and including Bartolomaeus Spranger's *Holy Family* (1982.710), a fully developed model for an engraving by Hendrick Goltzius.

5. See J. Bober, *Prints of the Ancien Régime* (Austin, 1996), especially 4–5.

6. On the history and character of the Suida-Manning Collection, see J. Bober, "La Collezione Suida-Manning: un'introduzione alla sua storia," in J. Bober and G. Bora, *Capolavori della Suida-Manning Collection* (Milan, 2001), 15–23, and Bober 2001, 34–62, each with preceding bibliography.

7. A convenient list of the seventeenth-century French paintings now in The Blanton appears within "American Museum Acquisitions of French 17th-century paintings since 1982" in P. Hunter-Stiebel, *The Triumph of French Painting: 17th Century Masterpieces from the Museums of FRAME* (Paris, 2003), 34–35.

8. One learns from the Mannings' confidants and others knowledgeable about the market at the time that works were often sold quietly or traded with no tangible record.

9. These materials, gathered from the Mannings' home in Forest Hills, New York, fill 13 four-drawer file cabinets, 38 flat archival boxes, and 66 cardboard boxes. They have been generally surveyed, and any documentation obviously concerning the collection has been noted. But these materials have not been properly sorted, much less catalogued, and they are not available for consultation.

10. The typewritten list appears as a personal property floater attached to a homeowners' policy issued by the Norwich Fire Insurance Society, New York, for the period of September 1948 to September 1951. See Cremona 2001, 18–19 and 22, note 13.

11. This impression has been seconded and elaborated by the Mannings' daughter, Alessandra Manning Dolnier, in conversation with the author on several occasions.

12. B. Suida Manning and W. Suida, *Luca Cambiaso la vita e le opere* (Milan, 1958).

13. Oil on canvas, 134 x 98 cm.; see Cremona 2001, cat. III.8.

14. R. L. Manning, "Some Important Paintings by Simon Vouet in America," in *Studies in the History of Art Dedicated to William E. Suida on His Eightieth Birthday* (London, 1959), 294–303.

15. R. L. Manning, *Vouet to Rigaud: French Masters of the Seventeenth Century* (New York, 1967).

CATALOGUE

Notes to the Reader

Places and dates of artists' births and deaths are given in the following order: place of birth, date of birth, date of death, place of death (e.g., Paris 1703–1770 Paris).

For catalogued drawings, measurements are provided in centimeters with height preceding width; inches are given in parentheses.

When a drawing has a recorded provenance, it has been supplied.

Provenance and references are given in chronological order from earliest to most recent entries.

1. School of Fontainebleau
Designs for Priming Powder Flasks
16th century

Red chalk on cream laid paper

14.9 × 10 (5⅞ × 3¹⁵⁄₁₆)

Watermark: partial, bird on mount in circle; Briquet 12.250
(sources dating to last quarter of the sixteenth century)

Inscription: "Sentro lo Icara Gattolo." on verso,
at top center in brown ink

Provenance: Spencer A. Samuels & Co., Ltd., New York,
before 1976; Blanton Museum of Art purchase, 1982.

Archer M. Huntington Museum Fund, 1982.723.1-2

Based on an antique cameo, the profile portrait head of a
bearded man crowned with a laurel wreath is found on several
sixteenth-century flasks in European collections.[1] The versos
of the flasks show various narrative images.[2] Dating to the
second quarter of the sixteenth century, one such flask in the
Museo Nationale del Bargello in Florence bears both the
portrait head and the battle scene of three horsemen as
depicted in the present drawings (fig. 1).[3]

Analysis of this flask reveals that the original mount was
replaced with the current one in around 1580. The mount in
the Blanton drawings differs from that of the flask, upon which
it was likely modeled; therefore, a date prior to circa 1580 for
the drawings seems plausible. Moreover, a partial watermark
of a bird on the sheet with the battle scene is similar to one
dated to the last quarter of the sixteenth century.

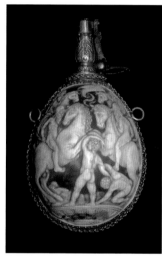

Fig. 1. Priming Flask, second quarter of the 16th century, shell;
mount: 1580. Museo Nazionale del Bargello, Florence.

1. I would like to thank Alexia Rostow for her diligence in pursuing the
sources for the Blanton drawings and finding the Bargello flasks.

2. See, for example, British Museum WB.230 or the powder flask in
Dresden, cat. 147b in Johannes Schöbel, *Fine Arms and Armor: Treasures in
the Dresden Collection*, trans. M.O.A. Stanton (New York, 1975).

3. Martha A. McCrory, "Renaissance Shell Cameos from the Carrand
Collection of the Museo Nazionale del Bargello," *The Burlington
Magazine* 130, no. 1023 (June 1988): 421, C 1806.

2. School of Fontainebleau
Venus and Cupid with River Gods
16th century

Black chalk, pen and brown ink, brown wash, heightened
with white on brown laid paper, laid down

25.4 × 39.4 (10 × 15½)

Inscriptions: "Denis Calvart" on verso, at bottom right in brown
ink; below that, "#18" in graphite; "C" at center in brown ink

Reference: AFA 1967, 12.

The Suida-Manning Collection, 517.1999

The attribution to Denys Calvaert (1540–1619) by a later collector is erroneous. The drawing shows none of the mass and volume characteristic of the Flemish artist's work.[1] It does recall the numerous reclining females that decorated the ceilings, walls, chimneypieces, and windows of French châteaus in the sixteenth century. The elongated and twisted bodies with small heads and feet, the planar treatment of the composition, and the tilted position of the nude suggest a bas-relief. The figure types, the elaborate hairstyle of Venus, the handling of the white highlights, and the heavy contour around the figure might point to an imitator of Luca Penni (1500/1504–1556), a Florentine artist who moved to Paris in 1530 and worked with Primaticcio and Rosso Fiorentino at Fontainebleau.[2] Although few of Penni's drawings or paintings survive, his work is best known through the engravings of Giorgio Ghisi, Léon Davent, and Étienne Delaune as well as tapestries made after his designs.

1. The Louvre holds examples of Calvaert's drawings, including some that are signed and dated. I would like to thank Henri Zerner for offering his opinion about this work.

2. See, for example, *Jupiter and Semele* (RF 3939), in the Louvre or *The Banquet of Achelous* (2007.111.141) at the National Gallery of Art, Washington.

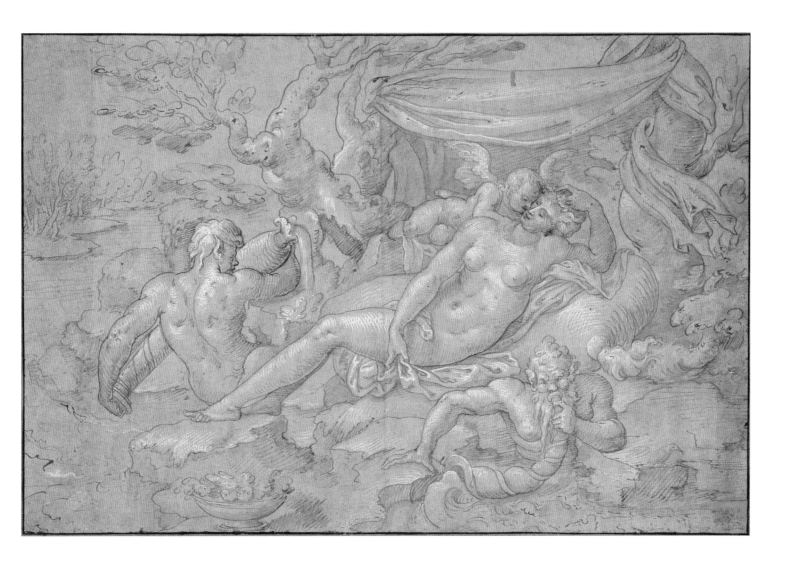

3. Attributed to Guy François
 Le Puy c. 1578–1650 Le Puy
 A Kneeling Female Saint
 Early 17th century

 Pen and brown wash, heightened with white on brown laid paper

 23.5 × 21.6 (9¼ × 8½)

 Inscriptions: Illegible initials at bottom right in ink;
 "57" at top left in ink

 The Suida-Manning Collection, 276.1999

This drawing of a modest female saint with a rosary at her waist came into the collection as an anonymous work from the seventeenth century and was later attributed to the circle of Simon Vouet (1590–1649). More recently, it has been suggested that it should be given to Guy François.[1] Making his sojourn in 1608, François was among the first French artists to study in Rome. He is credited with introducing Caravaggism into the provinces of France when he returned in 1613, but in figure type, facial expression, and a more subtle treatment of light, his style owes more to Carlo Saraceni (c. 1579–1620) than to Caravaggio.

Although much more elastic and dressed as a mendicant, the saint in the present sheet bears some resemblance to the figure of Saint Elizabeth of Hungary in a painting of the Holy Family (Musée de Brou, Bourg-en-Bresse) signed by the artist and dated 1626. Kneeling, both cross their arms over their chests and turn toward the left. A drawing of the Virgin and Child in the École des Beaux-Arts—arguably related to the *Holy Family* as well as another painting, *The Virgin of the Rosary*, 1619, in the church of Saint-Laurent, Le Puy-en-Velay—is equally instructive stylistically.[2] In like manner, the drapery falls stiffly over the body, the white highlights applied in dry, thin strokes that emphasize the sharp folds. The same exaggerated egg-shaped face with a high, rounded forehead, full cheeks, and bulging eyes distinguishes François's women. The hint of a smile playing across the lips of the saint here makes her perhaps more saccharine than his graceful Virgin.

1. Jonathan Bober and Jean-François Méjanès, personal communication, September 11, 2007.

2. Emmanuelle Brugerolles and David Guillet, *Poussin, Claude and Their World: Seventeenth-Century French Drawings from the École des Beaux-Arts* (Paris, 2001), 24–27. See also, Jean-Christophe Baudequin, "The Drawings of Guy François," *Master Drawings* 33, no. 3 (Fall 1994): 262–269.

4. Attributed to Jacques Callot
 Nancy 1592–1635 Nancy
 Study of a Man with a Turban
 c. 1617

 Red chalk on cream laid paper
 10.8 × 6 (4¼ × 2⅜)
 Inscription: Illegible marks on verso in ink
 The Suida-Manning Collection, 597.1999

Jacques Callot was a printmaker of remarkable genius and invention. He produced more than 3,000 prints and numerous drawings that demonstrate a keen observation of human nature. His panoramic landscapes, theater scenes, and views of amusements—such as *Fair at Impruneta*, 1620—are populated with hundreds of whimsical or fantastical figures. His portrait series of noble men and women as well as his depictions of dwarfs and beggars shows a limitless range. Even when his figures are misshapen or grotesque, they are always energetic and elegant.

Despite the dynamism and grace expressed in the present drawing, its attribution to Callot seems questionable. The work lacks the control and confidence seen in the red chalk drawings from the Louvre album (Musée Napoleon, 12513), which holds similar, isolated figures of Turks or Turkish soldiers in various poses.[1] The repeated strokes positioning the bent knee of the exaggerated *contrapposto* are absent in the figure studies, also executed in red chalk, on a sheet at the Yale University Art Gallery.[2] The emphatic modeling of the back and the smudged effect created by moistening the chalk at the shoulder blades and buttocks are uncharacteristic of Callot, as are the loopy gesture at the shoulder and the coarse handling of the drapery hanging from the figure's arms. The inscriptions on the verso (fig. 1), while illegible, appear to be in a seventeenth-century hand.

1. See especially, Louvre inv. 25106.

2. Suzanne Boorsch and John Marciari, *Master Drawings from the Yale University Art Gallery* (New Haven, 2006), 128, cat. 37.

5. Circle of Jacques Callot
Groups of Onlookers
Second quarter of the 17th century

Graphite, pen and iron gall ink on cream laid paper
Diameter: 8.3 (3¼)
The Suida-Manning Collection, 75.1999

The subject of this diminutive drawing is elusive. With the spectators splayed around the edges of the composition and a donkey at its center, one is tempted to label the work a Nativity. The lack of a clear focal point, however, belies that reading. Although the drawing came into the collection as "attributed to" Jacques Callot, scholars now question that claim. Callot's influence is apparent in the treatment of the drapery and foreshortening of the foreground figures, but the compressed space and *horror vacui* of the background group do not correspond to what we know of the master's graphic work.

Callot did have followers and an active studio. The present sheet could very well have been generated by one of them. One student, François Collignon (c. 1610–1687), has been the subject of some research.[1] Also a native of Nancy, Collignon apprenticed with Callot as a printmaker between 1626 and 1630 and left behind a considerable number of prints, some made after Callot and Stefano della Bella.[2] He was active in Augsburg and Rome, where he produced prints after Domenichino and Pietro Testa, among other Italian masters. No drawing by Collignon has been positively identified, however, making any stylistic analysis difficult at best.

1. J. Kuhnmünch, "Un marchand français d'estampes à Rome au 17e siècle: François Collignon," *Bulletin de la Société de l'Histoire de l'Art* (1978): 79–100.

2. P. Marot, "Jacques Callot: sa vie, son travail, ses éditions," *Gazette des Beaux-Arts* 86, no. 1283 (1975): 186–198.

6. Circle of Claude Vignon
 A Pawnbroker's Shop
 Late 17th century

Black and white chalk on buff laid paper

30.8 × 42.6 (12⅛ × 16¾)

The Suida-Manning Collection, 592.1999

This sheet came into the collection as "circle of Claude Vignon" (1593–1670) probably because of the costumes with feathered hats and expansive breeches that were a typical fashion of the early seventeenth century, but the composition and style are closer to works from the generation following Vignon's death.[1] Small, indecipherable notations, possibly about color, are barely visible on the tablecloth and on the cloak of the standing male figure. The subject, initially identified as a pawnbroker's shop, is equally obscure and possibly drawn from literature or the theater. The tilt of the floor and the arrangement of the action horizontally across the picture plane suggest a stage set. An interior scene of well-dressed men gathered around a table piled with coins juxtaposed with two women near a chest placed on the floor nearby could just as easily refer to a marriage contract or dowry. No textual source for the subject has yet been found.

1. Paola Bassani, *Claude Vignon, 1593–1670* (Paris, 1992). See pp. 507–523 for rejected paintings.

36

7. Circle of Nicolas Poussin

Moses Striking the Rock

Late 17th century (after Nicolas Poussin, 1649)

Red chalk, pen and brown ink, brown wash on laid paper,
laid down on heavy card

41.9 × 55.9 (16½ × 22)

Inscription: "Sebastien Bourdon" at bottom right of mount
in brown ink

The Suida-Manning Collection, 61.1999

Nicolas Poussin (1594–1665) produced three versions of this subject over the course of his career.[1] The first painting of 1637 is in the National Gallery of Scotland, Edinburgh; the second, dating to 1649, is now in the Hermitage in St. Petersburg; and the third is lost. All three works were reproduced as engravings, and a battery of drawings for each of the compositions is known.[2] In addition, there are many copies and reductions made by students, followers, and emulators.[3] Poussin's variations on this theme were widely known and highly regarded.

The underdrawing of the present sheet suggests it is a study for an independent composition by a later artist who was clearly familiar with the paintings, the copies, or their engraved reproductions. The attribution to Sébastien Bourdon (1616–1671) seems unlikely when compared with his treatment of the subject, which is now lost and known only through a copy (National Museum, Stockholm).[4] While the overall composition organized around a centralized outcropping of rocks directly quotes Poussin's second version of the subject, the arrangement of the figures and the groupings differ markedly. The women and children in the right foreground of the painting are moved to the left corner and their positions made more upright and intense in the drawing. In the drawing there is more distance between the foreground and middle ground, with Moses almost entirely isolated from the surrounding figures. He steps forward and gestures

forcefully. The male figure on the left, cropped by the edge of the sheet, leans forward and reaches toward Moses and the water source. In the painting Moses stands straight, and the kneeling figure behind him drops his arms to the side. In the right foreground of the drawing, the male figure bending over and looking back over his shoulder is nowhere to be found in Poussin's compositions. However, this is a good example of Poussin's influence on generations of French artists and—equally importantly—of the stages of an artist's development: from dutifully copying a master to exploring variations on an established theme.

1. Christopher Wright, *Poussin Paintings: A Catalogue Raisonné* (New York and London, 1984), 180–181 and 247.

2. Georges Wildenstein, *Les Graveurs de Poussin au XVIIe siècle* (Paris, 1957), 45–48. See also, Walter Friedlander, *The Drawings of Nicolas Poussin: Catalogue Raisonné* (London, 1976), 12–17.

3. See, for example, Antoine Bouzonnet-Stella, oil on canvas, in the Louvre, MG 957.

4. Jacques Thuillier, *Sébastien Bourdon, 1616–1671: catalogue critique et chronologique de l'oeuvre complet* (Paris, Montpellier, and Strasbourg, 2000), 372 and 464–465. Jean Jouvenet comes to mind as well, and while no such painting is recorded in his catalogue raisonné (Schnapper), there is a reference to just such a composition, presumably lost. Guillet de Saint-Georges, *Mémoires inedits sur la vie et les ouvrages des membres de l'Académie royale de peinture et de sculpture,* ed. L. Dussieux, E. Soulie, Ph. de Chennevières, Paul Manz, and A. de Montaiglon, rev. ed. (1682; repr., Paris, 1854 and 1968), vol. 2, 23.

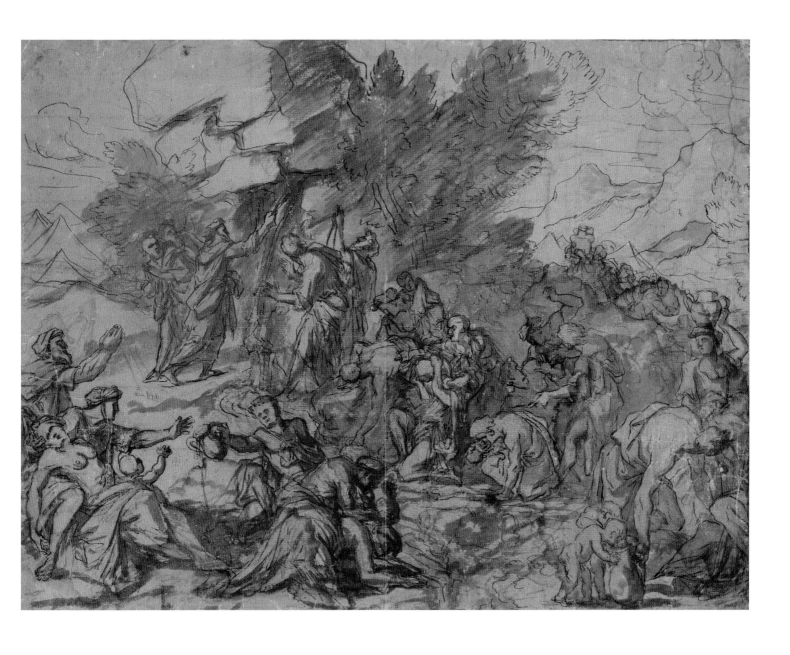

8. Jean de Saint-Igny
 Rouen c. 1600–after 1649 Paris
 Possibly Saint Dorothy
 Second quarter of the 17th century

Red chalk on cream laid paper

22.2 × 14.6 (8¾ × 5¾)

Watermark: Variant of Briquet 12803 (1580–1594) and more similar to Heawood 3583 (1621)

The Suida-Manning Collection, 510.1999

The red chalk drawings of Jacques Bellange and Jean de Saint-Igny have long been confused, and it is precisely this kind of exercise in connoisseurship that appealed to both William Suida and Robert Manning. A very similar work on the art market in 1981 of a full-length, seated female with a small, egg-shaped head and abbreviated facial features, awkward oversized hands and short, strong diagonal strokes used to model the drapery was attributed to Bellange.[1] Much work over the last twenty years, however, has resulted in a disentangling of these two artists' oeuvres.[2] Christopher Comer's reattribution of works traditionally given to Bellange to Saint-Igny was based partly on the paper source: Bellange's paper was manufactured in Lorraine. The Blanton sheet bears a watermark associated with mills in Calais, supporting an attribution to Saint-Igny.

Saint-Igny was born in Rouen, where he apprenticed, but he made his way to Paris some time in the 1620s. He never visited Italy, instead drawing his inspiration from the second School of Fontainebleau, the mannerist prints of Jacques Callot and Jacques Bellange (which accounts for much of the confusion), and the northern impulses fashionable in Paris in the first quarter of the century. He is especially notable for his drawing manual, *Elemens de pourtraiture*, published in Paris in 1630 with subsequent editions.

1. Adolphe Stein, *Master Drawings* (London, 1981), cat. 9, plate 7.

2. *Dessins français du XVIIe siècle dans les collections publiques françaises* (Paris, 1993), 114–117; Hilliard Goldfarb, *From Fontainebleau to the Louvre: French Drawing from the Seventeenth Century* (Cleveland, 1989), 151–152; Susan Welsh Reed, *French Prints from the Age of the Musketeers* (Boston, 1998), 110–111; *Poussin, Claude and their World: Seventeenth-Century French Drawings from the École des Beaux-Arts* (Paris, 2001), 80–92; Christopher Comer in *Maîtres français, 1550–1800: Dessins de la donation Mathias Polakovits à l'École des Beaux-Arts* (Paris, 1989), 82.

9. Circle of Laurent de La Hyre
The Daughters of Hesperus
Middle to late 17th century

Black chalk and brown wash on antique laid paper

18.1 × 33 (7⅛ × 13)

Watermark: Monogram "IHS" with cross above and possibly three arrows below enveloped in a sunburst; cf. Heawood 2952

The Suida-Manning Collection, 351.1999

In Greek mythology, the daughters of Hesperus were the guardians of the golden apples given to Hera upon her marriage to Zeus. The nymphs, known for their gift of song, were aided in their task by the dragon Ladon. As one of his labors, Heracles was commanded to slay the dragon and steal the apples. Depictions of the nymphs in their gardens evoke nostalgia for an idyllic life before the fall.

The disposition of the figures and the steep perspective suggest that the drawing was intended as a ceiling decoration or to be placed over a door, possibly for a garden room or a lady's chambers. There is some skepticism that this drawing belongs to the circle of Laurent de la Hyre, whose studio was extensive and prolific, or even that it is French.[1] The proportions of the figures and their facial types bear some resemblance to the master's style, but the anatomy and the overall weightiness of the composition, combined with the shape of the design, suggest a German connection.

1. For a discussion of La Hyre's work and studio, see Pierre Rosenberg and Jacques Thullier, *Laurent de la Hyre* (Geneva, 1988) and Hilliard T. Goldfarb, *From Fontainebleau to the Louvre: French Drawing from the Seventeenth Century* (Cleveland, 1989), 164–175. Most recently, a catalogue of La Hyre's drawings from the Louvre was published: Madeleine Pinault Sørensen, *Laurent de La Hyre* (Paris and Milan, 2009).

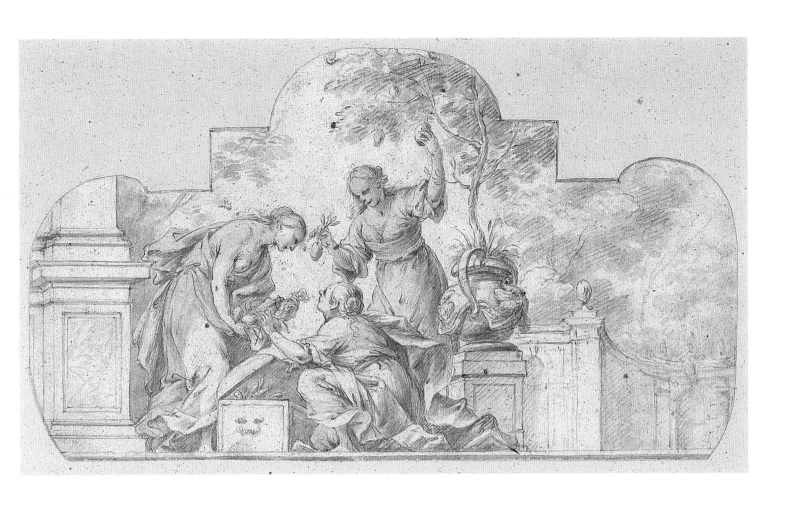

43

10. Circle of Daniel Hallé

A Warrior amid Classical Ruins

Middle to late 17th century

Black chalk and brown wash heightened with white on brown laid paper

39.4 × 27.9 (15½ × 11)

Inscription: "étude academique du pompier sortant du Cabinet de Crozat et achette [possibly] 72 livre a sa vente / [paraphe]" on verso, at top center in brown ink

Provenance: Crozat sale, Paris, c. 10 April 1741.

The Suida-Manning Collection, 327.1999

Although its condition is compromised, the drawing is an accomplished example of a seventeenth-century academic figure study set amid classical ruins. The inscription on the verso in a nineteenth-century hand suggests that it came from the sale of Pierre Crozat's collection in 1741 (fig.1). Unfortunately, the descriptions of the lots in that catalogue are not detailed enough to identify particular works. The use of the word *pompier* is interesting in that the term was used pejoratively in the nineteenth century to describe academic art that had become *retardataire*; that is, art that had relied too heavily on the practice of making hackneyed copies of classical antique models.[1] Its use to refer to a seventeenth-century sheet is unusual but not inappropriate. In France, *pompier* referred to firemen who donned helmets similar to those worn by soldiers pictured in classical Greek art. It was common studio practice for models to wear firefighters' helmets to suggest Greek or Roman soldiers.

1. See, for example, Jacques-Louis David's *Leonides at Thermopylae*, 1814, Paris, Musée du Louvre; and Honoré Daumier's *Combat des écoles: l'idéalisme et le réalisme*, 1855, lithograph.

Fig. 1. Verso with inscription and paraph.

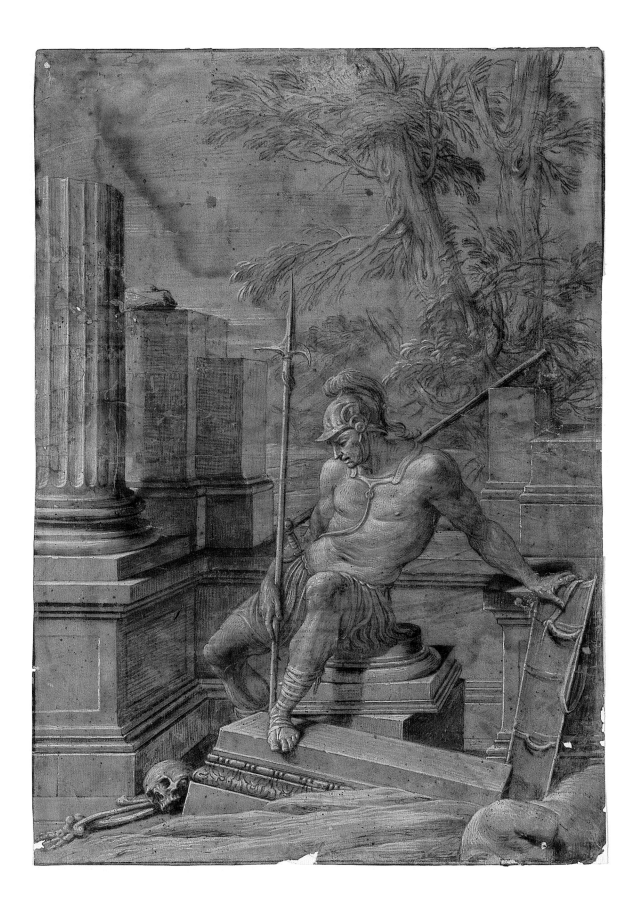

11. Michel Dorigny

Saint-Quentin 1617–1665 Paris

The Annunciation

c. late 1650s–early 1660s

Pen and brown ink, squared in black chalk on cream paper, laid down

20.6 × 18 (8⅛ × 7¹⁄₁₆)

References: Ontario 1972, 156, cat. 44; Brejon de Lavergnée, 429.

The Suida-Manning Collection, 232.1999

This drawing is among the better-known works in the Suida-Manning Collection. Pierre Rosenberg used it to reattribute to Dorigny a painting of an Annunciation in the Uffizi that had long been given to Simon Vouet. An even closer match for the drawing was found in a painting now located in the church of Saint-Michel in Sillery, Québec.[1] Research into the collectors responsible for bringing the painting to Canada revealed an inventory listing an Annunciation and identifying the artist as "Dorigni," thereby confirming the attribution of the painting and, by extension, the related drawing in Austin to this artist.[2] Since then, Dorigny has become the object of more study, and his oeuvre is expanding as reassessments continue. He is currently recognized as a significant link between Simon Vouet and the more classicizing style of Charles Le Brun.

Dorigny never traveled or worked in Italy, but he came into contact with its artistic principles through Vouet, who employed him in his studio as a reproductive printmaker and assistant. When Vouet died in 1649, Dorigny, who had married Vouet's daughter a few years before, established an independent studio and earned commissions of his own. This drawing, squared for transfer, was likely made long after Vouet's death—possibly the late 1650s or early 1660s—when his influence over Dorigny was waning and other trends in Paris were emerging.

1. Ontario 1972, 156; and Brejon de Lavergnée, 429–430.

2. Gérard Morisset, "La Collection Desjardins à l'église de Sillery et ailleurs," *Le Canada français*, no. 8 (April 1935): 734–746.

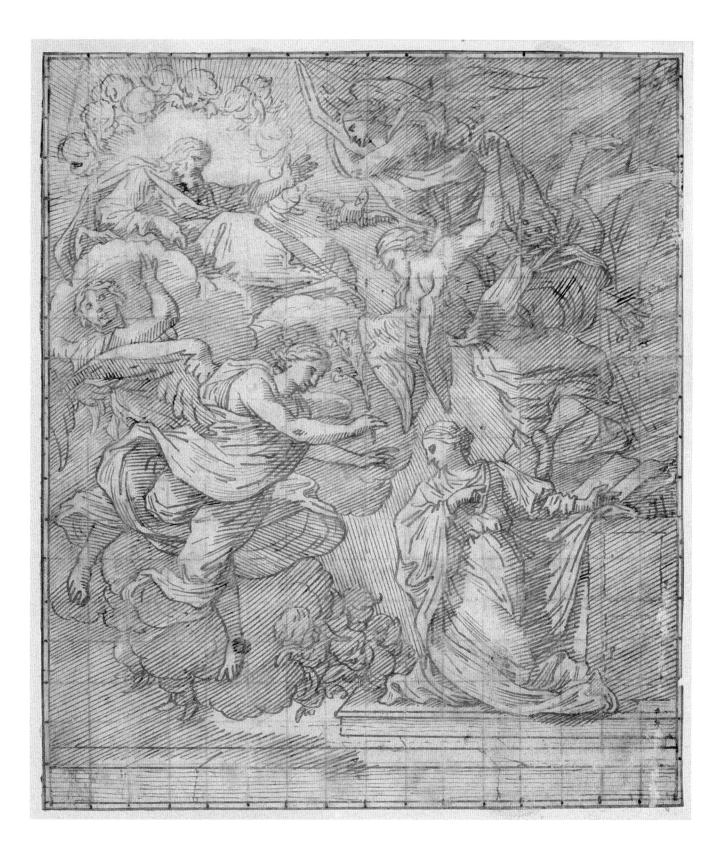

12. Workshop of Philippe de Champaigne
Study of a Monk (1 and 2)
Third quarter of the 17th century

Black and white chalk on gray laid paper

38.1 × 26.7 (15 × 10½)

Watermark: Grapes in a circular band with indecipherable letters, cf. Heawood 2427–2432

The Suida-Manning Collection, 645.1999 and 177.1999

These drawings are closely related in style and technique to figure studies of monks at Harvard University and the Courtauld Institute of Art, all originally from the Robert Witt Collection. The hatching is similarly broad and regular; the proportions of the heads and the facial features, foreshortened though they are in the Blanton sheet, are full and round; and the treatment of the drapery in all of the sheets is stiff and angular. Furthermore, the paper is similar in size and type. Clearly some of these are by the same hand, though it is unclear whose.

Once thought to be by Jean-Baptiste de Champaigne, the present sheets were later attributed to Louis Licherie de Beuron based on the study by Alain Mérot of Eustache Le Sueur.[1] Mérot suggested the attribution to Licherie, who—along with Claude II Audran and Jacques Bouzonnet-Stella—was commissioned to provide a cycle of paintings for the Carthusian monastery at Bourgfontaine in Valois. According to a manuscript written by Guillet de Saint-Georges, Audran and Bouzonnet-Stella died shortly after receiving the commission, leaving Licherie to produce only eight paintings in the series.[2] These paintings are lost, and at present no prints recording them have been located. Only one autograph drawing of a composition by Licherie is known (Stuttgart), and it does not especially support an attribution of the Blanton sheet to this artist.

More recently, however, it has been suggested that the Harvard sheet (fig. 1) to which the Blanton studies bear so much resemblance is related to the cycle of St. Benedict for Val-de-Grace, commissioned by Anne of Austria from Philippe de Champaigne around 1656. Similarly, the Courtauld sheet is a figure study for the monk at the far right of the painting *The Ax Reattached to Its Handle* from that cycle of twelve paintings. The Blanton drawings bear no relation to any of the figures in the eight known paintings from that commission, now in

Brussels (the other four are lost). Indeed, the standing figure of a monk, squared for transfer, is wearing a Carthusian habit, distinguished by the wide bands loosely fastening the scapular at the thighs. Philippe de Champaigne did receive several commissions from the Carthusians between 1655 and his death in 1674, only a very few of which survive.[3] The Blanton sheets could be workshop drawings from one of those commissions.

1. Alain Mérot, *Eustache Le Sueur* (Paris, 1987), 195.

2. *Mémoires inedits sur la vie et les ouvrages des members de l'Académie royale de peinture et de sculpture,* ed. L. Dussieux, E. Soulie, Ph. de Chennevières, Paul Manz, and A. de Montaiglon, rev. ed. (1682; repr., Paris, 1854 and 1968), vol. 2, 67–68.

3. See *Saint Bruno in Prayer*, Nationalmuseum, Stockholm; *The Vision of Dom Jean*, destroyed by fire and known from a drawing in the Petit Palais, Paris.

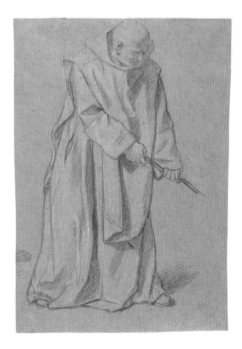

Fig. 1. Workshop of Philippe de Champaigne, *Monk Pulling on a Rope*, black and white chalk on antique laid paper, 34.3 × 23.6 (13½ × 9⁵⁄₁₆), Harvard University Art Museums/Fogg Art Museum, Gift of Sir Robert and Lady Witt, 1929.246

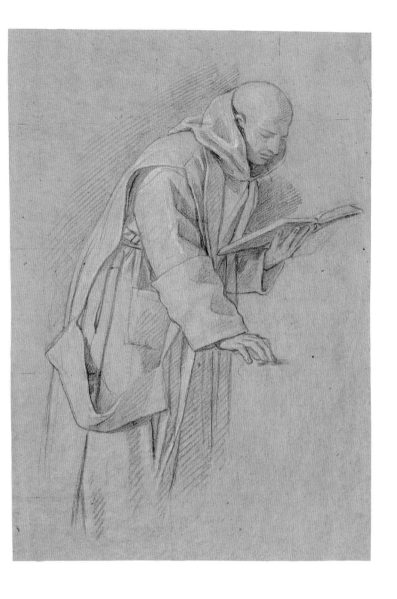

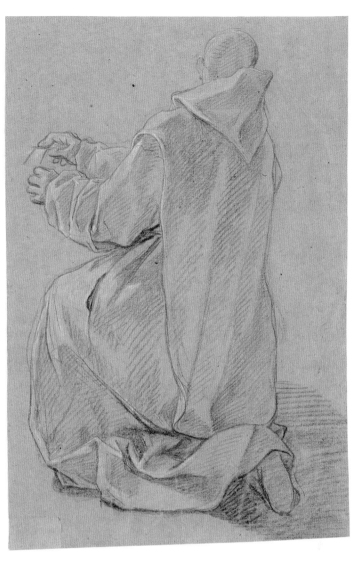

49

13. Valentin Lefebvre

Brussels 1637–1677

Esther and Ahasuerus

Third quarter of 17th century

Pen and brown ink, brown wash, squared in red chalk on laid paper, lined

25.2 × 34.8 (9¹⁵⁄₁₆ × 13¹¹⁄₁₆)

Inscriptions: "(See my notes about this / [illegible] 22.1.21) / traced but not recorded" at top right in graphite; "[?] 790" at center in graphite: "not traced in Veronese" at bottom right in graphite; "What is written under here" on verso, at top center in graphite

The Suida-Manning Collection, 363.1999

Not much is known about Lefebvre's training and early career other than he left his native Flanders—long a battleground of the French, Spanish, and Dutch—for Venice while still quite young. Recognized as a portrait painter in the manner of Veronese, Lefebvre produced a good amount of religious works as well, and he is notable for the bound volume of etchings reproducing the works of Veronese and Titian published in 1682.[1]

The present drawing of *Esther and Ahasuerus* was clearly inspired by Venetian masters, although it is far more dramatic in its action and lighting effects.[2] Despite its being squared for transfer, the work could be the earliest of a series of three known preparatory drawings for two finished paintings of the subject.[3] In the Blanton drawing, the diagonal composition is reversed with the seated king—on a dais with a canopy at left—thrusting his scepter toward Esther at right. She falls back into the arms of two maidservants, and her foreshortened head is framed by a grand arch in the background. The king's face is partially blocked by his shoulder, and the expanse of his back is prominent as he twists violently on axis. In the final versions of the composition with Ahasuerus on the right, Lefebvre gives a frontal view of the king's torso and face but casts the figure entirely in shadow. Through the series of preparatory drawings, the artist made substantial changes to the architectural backdrop, finally aligning Esther with the corner of the pavilion, throwing a brilliant light on her pale, limp body and adding a third servant to help support her weight. The little dog in a play bow at her feet in the Blanton sheet is absent from the St. Petersburg version of the painting (fig. 1) and all three of the drawings; the pet is replaced by two larger hounds in the center. In the alternate version (private collection), the dog appears again at her feet, this time jumping toward her, next to its larger counterparts.

1. *Opera selectiore quae Titianus Vecellius Cadubriensis et Paulus Calliari Veronensis pinxerunt quae que Valentius LeFebre*, Venice 1682.

2. Veronese treated the subject twice, first in 1556 for the ceiling of the nave of San Sebastiano in Venice and again in a painting on canvas, c. 1560, now in the Kunsthistorisches Museum in Vienna. Tintoretto likewise painted two versions of Esther before Ahasuerus. The canvas painted in 1546–1547 was recorded in the Gonzaga Collection inventory in Mantua in 1627 and later acquired by Charles I of England, whose collection was sold in 1650 after his execution. It was reacquired during the Restoration after 1660, and it has remained in the royal collection in London. Tintoretto painted another version, undated although thought to be later than the canvas in the royal collection, as one in a series of six ceiling panels of Old Testament scenes. It was acquired by Velázquez in Venice in 1649 for Philip IV. See *Tintoretto*, ed. Miguel Falomir (Madrid, 2007), 225 and 262–263. Whether Lefebvre knew of these either from printed reproductions or copies is unknown.

3. Ugo Ruggeri, *Valentin Lefèvre: dipinti, disegni, incisioni* (Manerba, Reggio Emilia, 2001), Q 35, 113 and D 71–73, 165. Ruggeri cites Rodolfo Pallucchini, *La pittura veneziana del Seicento*, vol. 2, (Venice, 1981), fig. 988 for an illustration of the alternate version now in a private collection.

Fig. 1. *Esther before Ahasuerus*, third quarter of the 17th century, oil on canvas, 100 × 121 cm. The State Hermitage Museum, St. Petersburg, GE-1201

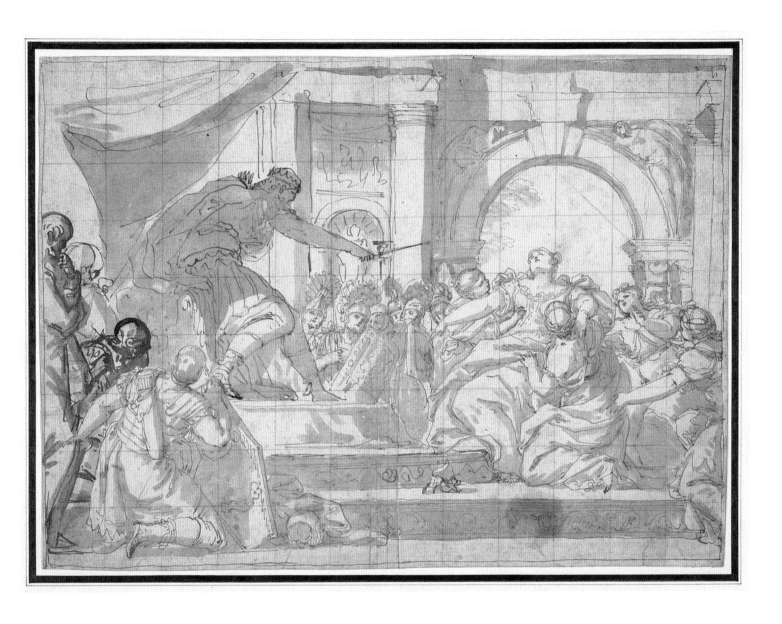

14. Michel Corneille the Younger

Paris 1642–Paris 1708

Aspasia among the Philosophers of Greece

c. 1699

Black and white chalk heightened with white on blue paper, laid down

30.2 × 54 (11⅞ × 21¼)

Inscriptions: "D107" at bottom left of mount in ink; "Michel Corneille" at bottom right of mount in ink ; "107" on verso, at bottom left in graphite; "Aspasie" on verso, at center in graphite

The Suida-Manning Collection, 189.1999

The present sheet was initially cataloged with the title of *An Allegory of the Arts.*[1] It is, in fact, a counterproof possibly made from the drawing in the Horvitz Collection at Harvard University of *Aspasia among the Philosophers of Greece* (fig. 1). These two drawings and several others are related to two paintings by the artist: one made for the ceiling of the Salon des Nobles in the Queen's quarters at Versailles around 1673 and a second, later variation possibly exhibited at the Salon of 1699.[2] In his study of this group of drawings, Pierre Rosenberg cited a counterproof in Russia,[3] (fig. 2) but did not mention the example in the Suida-Manning Collection.

A counterproof is made by dampening a drawing and pressing another sheet against it to lift off the image. Because counterproofs and the drawings from which they are made have been either rubbed or run through a press, the fibers of the paper tend to be compressed and the medium—in this case, chalk—has a uniform quality in texture and depth, as is true here. Artists made counterproofs for use in their studios by students, as records of completed commissions, as a means of transferring an image to a copper plate to be engraved or etched, or as a marketable copy. Given the blue paper, it seems that the Blanton drawing may have served this last function.

Renowned for her intellect, Aspasia was the mistress of Pericles and the subject of works by several Greek authors, including Xenophon, Aeschines, and possibly Plato, making her a fitting allegory for a queen's chambers.

Fig. 1. *Aspasia among the Philosophers of Greece*, Harvard University Art Museums, Fogg Art Museum (loan from the Collection of Jeffrey E. Horvitz).

Fig. 2. *Aspasia among the Philosophers of Greece*, early 1670s, counterproof from the sketch for a ceiling in the Salon de la Reine in Versailles, red chalk, 22 × 34 cm. The State Hermitage Museum, St. Petersburg, OR 2648.

1. The Sotheby's appraisal, made before the Suida-Manning Collection was acquired by The Blanton Museum, lists the title simply as *The Arts.*

2. Pierre Rosenberg, *From Callot to Greuze: French Drawings from Weimar* (Berlin 2005), 102–103.

3. Irina Novoselskaya, "The Drawings of Michel Corneille, II," *Bulletin of the National Museum of the Hermitage* 18 (1960): 29–31. I want to thank Tatiana Segura for providing a translation of this article for me.

15. Attributed to Étienne Allegrain

Paris 1644–1736 Paris

A Classical Landscape

c. 1700

Pen and brown ink, brown wash heightened with white, laid
down on card

27.9 × 40.6 (11 × 16)

Inscriptions: "G. Poussin (dit le Guaspre) / Beau frere et eleve de
Nicolas Poussin / 1613–1675 Ec Fr" on verso, at bottom right in
graphite; "No. 20" on verso, at bottom left in ink

The Suida-Manning Collection, 234.1999

While the inscription on the verso of this drawing attributing
it to G. Poussin, to whom we refer today as Gaspard Dughet
(1615–1675), seems to miss the mark, the attribution to Allegrain
seems plausible. Not much is known of this artist before he
was accepted into the academy in 1676. What can be gleaned
from the handful of signed paintings and even fewer drawings
and documented commissions—chiefly those landscapes in
the Grand Trianon executed in 1694–1695—is scant indeed.[1]
Although he produced a good amount of "classical" landscapes
redolent of the Italian countryside, no evidence suggests he
ever traveled or studied there. Instead, he was much influenced
by the landscapes of Nicolas Poussin (1594–1665) and relied
heavily on the myriad etchings and engravings that circulated
in Paris.

The Blanton drawing shares with some of Allegrain's
known paintings certain compositional devices derived from
Poussin's landscapes: the conception of space as a series of
distinct horizontal planes; the jagged path or river's edge that is
meant to transition through the space; the blocky handling of
mass; and the use of bright light and deep shade to animate the
surface. This is a finished drawing and a highly intellectualized
view of nature entirely conceived and executed in the studio.

1. Anne Lossel-Guillien, "A la recherché de l'oeuvre d'Étienne Allegrain,
paysagiste de la fin du regne de Louis XIV," *Histoire de l'art* (1988): 69–78.

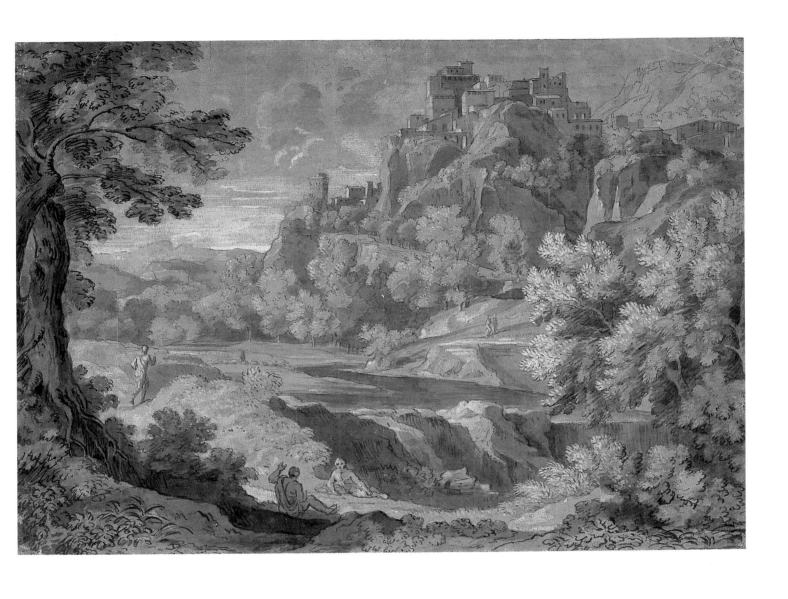

16. Jean-Baptiste Jouvenet
Rouen 1644–1717 Paris
Studies of a Standing Man
c. 1700

Black and white chalks on gray paper, laid down

37.6 × 25.2 (14¹³⁄₁₆ × 9 ¹⁵⁄₁₆)

Provenance: Julius H. Weitzner; Robert Lee Manning (1924–1996).

References: AFA 1966, 11 [exhibited as Vouet]; Ontario 1972, 167; Schnapper 1974, 228; BMA 1999, 45; BMA 2006, 76.

The Suida-Manning Collection, 343.1999

Robert Manning believed this drawing to be by Simon Vouet (1590–1649), an artist credited with introducing contemporary Italian style to the French court when Louis XIII called him back to Paris from Rome in 1627. The sheet was reattributed to Jean Jouvenet by Pierre Rosenberg in 1972, and a date around the turn of the eighteenth century was subsequently suggested based on similarities with figures from the artist's late paintings. Although Jouvenet never traveled to Italy, he trained with Vouet's most important student, Charles Le Brun (1619–1690), who did study in Rome. Any Italian qualities in his manner of drawing are likely a synthesis of these two sources.

After beginning his career with Le Brun, Jouvenet enjoyed much success as a history painter, earning many commissions to decorate state buildings and private residences. He was admitted as a member of the faculty at the Académie royale and was elected director in 1705. In these pedagogical roles he had much impact on successive generations of artists, including François Boucher (cat. 32), who owned several of Jouvenet's drawings. Jouvenet was especially admired for the vigor of his style, the confidence of his handling, and a geometric clarity that is the hallmark of French draftsmanship.

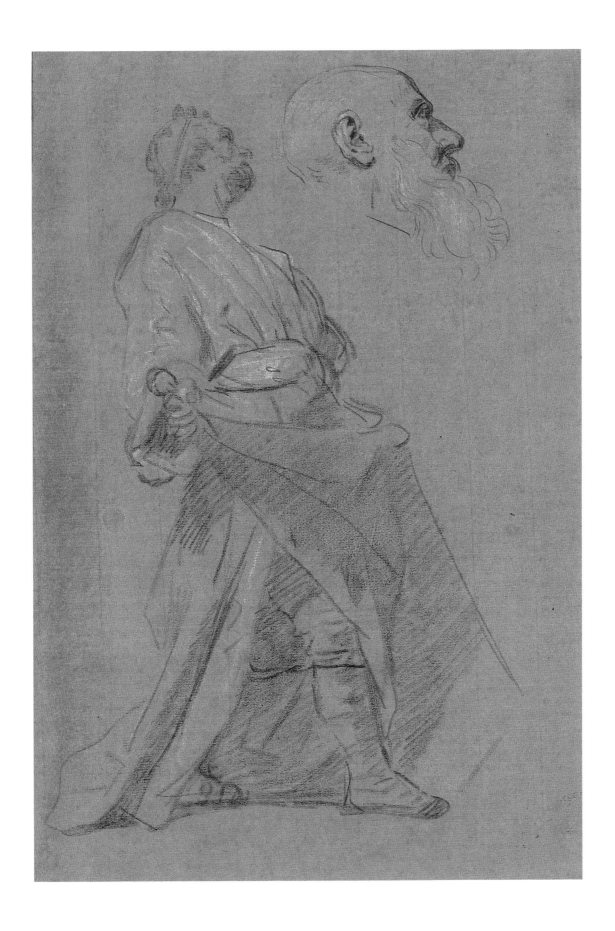

17. François Verdier

Paris 1651–1730 Paris

Mercury with Nymphs and Satyrs

c. 1690s

Black and white chalk on laid paper, three sheets joined and
mounted on laid paper with thin blue border added

30.5 × 41 (12 × 16⅛)

Inscriptions: "Old cartoon for tapestry design" on verso, at top left
in graphite; "Boucher ?" erased, below that

The Suida-Manning Collection, 583.1999

Verdier's gift for draftsmanship was recognized early in his
career while he was a student at the Académie royale (1668–
1671). There he was accepted as a member in 1679 and spent
only a year at the Académie de France in Rome, returning
to Paris in 1680. He worked with Charles Le Brun on the
Apollo Gallery at Versailles and from 1688 until 1698 produced
fourteen mythological paintings for the decoration of the
Grand Trianon. He taught at the Académie royale and, like
many of its professors, produced a suite of figure studies for his
students to copy. Nicolas de Poilly the Younger engraved and
published the drawings in 1749, extending Verdier's influence
well into the eighteenth century.

The present sheet is similar in subject, scale, and construction
to one found in the Kunsthalle in Bremen, Germany, depicting
Mercury leading the goddesses Juno, Minerva, and Venus to
Paris for judgment.[1] In both drawings, a central sheet of paper
is joined with thin strips on either side to extend the landscape
and change the orientation from vertical to horizontal.[2] The
portion of paper added on the left has an underlying residue of
red chalk, bearing no relation to the black chalk drawing over
it, suggesting the artist reused a scrap of paper from his studio.
Despite the notation on the verso of the sheet identifying it
as cartoon for a tapestry design, no related finished work has
been found.

1. For an illustration of this drawing, see the Frick Art Reference Library
file on this artist.

2. Verdier similarly treated a drawing now at The Art Institute of Chicago.
See cat. 18 for a description of that work.

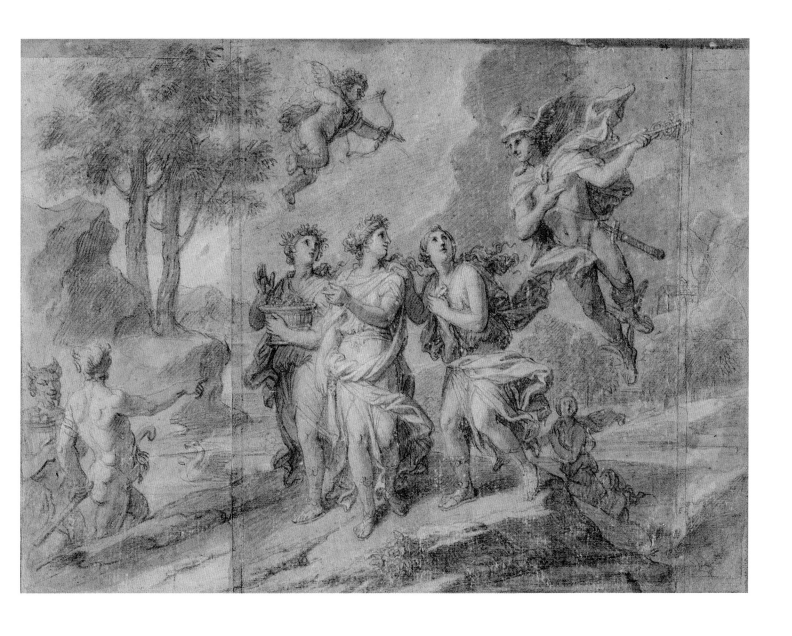

18. François Verdier

Paris 1651–1730 Paris

Hercules on Olympus

c. 1699

Black and white chalk on blue laid paper

30.5 × 55.3 (12 × 21¾)

Reference: AFA 1966, 12.

The Suida-Manning Collection, 582.1999

The apotheosis of Hercules, who according to legend was the tenth king of Gaul, was a popular theme in the seventeenth and eighteenth centuries.[1] Charles Le Brun, with whom Verdier worked at Versailles, painted a notable image for the Hôtel Lambert in Paris between about 1650 and 1662. Taken from book nine of Ovid's *Metamorphoses*, Le Brun's scene depicts the Greek hero's arrival in Olympus after his death and cremation. Hercules, clad in his lion skin and carrying his club, strides forcefully toward Jupiter enthroned. Juno reclines nearby, and Diana with her diadem of a half-moon and spear stands behind her. An allegory of Time, recognizable by his scythe, takes up a position behind Jupiter. Mercury hovers overhead, and the rest of the Roman pantheon is assembled in a left-to-right wedge-shaped composition that underscores the sensation of ascension.

Two very similar works by Verdier are found in the Musée Atger in Montpellier and in The Art Institute of Chicago (figs. 1 and 2). The Montpellier drawing is roughly the same size as the Blanton image, but it has been cut down and mounted to another sheet of paper and inscribed "Verdier monspeliensis fecit" in the bottom left of the mount. The Montpellier sheet shows variations in the disposition of the figures and includes a view of a city in the lower right corner. The composition is less coherent and more pyramidal than that of the Blanton work. Smaller and with added strips of tan laid paper at either end, then laid down on ivory paper, the Chicago sheet is sketchier and arrives at an arrangement closer to the drawing in Austin. No corresponding painting has been identified. No date has been proposed for any of the three drawings, but the high finish and blue paper of the Blanton example might suggest a date after 1699, when Verdier left his post at the Académie royale and relied on his talents as a draftsman for income.

1. André Chastel, *French Art* (Paris, 1996), 55–56.

Fig. 1. *L'Apothéose d'Hercule*, chalk and wash with white highlights, 28 × 57 (11 × 22.4), Musée Atger, Montpellier, MA 240.

Fig. 2. *Gods on Olympus*, black chalk, brush and gray wash on tan laid paper, 16.8 × 31 (6.6 × 12.2), The Leonora Hall Gurley Memorial Collection, Art Institute of Chicago, 1922.280.

19. Attributed to Raymond Lafage
 Lisle-sur-Tarn 1656–1684 Lyon
 The Elevation of the Cross
 c. 1680

Black chalk, pen and brown ink on laid paper mounted to another sheet

38.7 × 27.3 (15¼ × 10¾)

Inscriptions: "Lafage fecit" at bottom left in brown ink; "L'Elevation de la Croix" at bottom center in brown ink

The Suida-Manning Collection, 353.1999

Lafage's rapid and spontaneous sketches stand in stark contrast to the deliberate and meticulous studies produced both by his peers and the Italian masters most sought after by contemporary collectors. After Lafage returned to Paris from a year in Rome, the Dutch engraver and art dealer Jean Vander Bruggen recognized and capitalized on the artist's remarkable skill and facility. In 1682, the two traveled to Brussels where—in what might be construed as the earliest example of performance art—Lafage dashed off finished drawings of randomly selected subjects before amused audiences. After the artist's untimely death at the age of 28, Vander Bruggen continued to promote him, publishing engravings after his drawings and elevating him to the ranks of Raphael and Michelangelo.[1] Patrons had commissioned Lafage to produce drawings and murals over the course of his short career, and Pierre Crozat acquired his first drawing from him in 1682 in Toulouse after the artist returned from Brussels. Crozat went on to collect many Lafage drawings.

The present drawing is intriguing, if not wholly convincing, as an example of Lafage's work. The sheet is an amalgam of several different drawings pasted together (see Grant's essay in this catalogue). The lower right corner of the uppermost sheet is torn off and "repaired" by the addition of another drawing entirely unrelated to the central image. Similarly, a small section of the bottom left corner is missing, but here the additional scrap was clean, leaving space for the signature "Lafage fecit." A close examination reveals that the "t" in "fecit" bled onto the central sheet, suggesting that it was inscribed after the fill was added. A variation of the Elevation is visible in transmitted light on the verso, and the sheet is laid down on another drawing, the subject of which is difficult to discern. The composition is characteristically dynamic and the strained, muscular bodies are in keeping with Lafage's virtuoso style. The kneeling figure at the far left is strikingly similar in handling to one crouched over in the left foreground of *The Martyrdom of Saint Lawrence*.[2] The body of Christ, however, seems too elegant, the soldier and horse too precious, and some of the figures unresolved in their foreshortening. Whether it is an autograph drawing, a workshop collaboration, or a contemporary pastiche, this sheet remains a compelling document of studio practice in the seventeenth century.

1. *Recueil des meilleurs dessins de Raimond Lafage: Gravé par cinq des plus habiles graveurs et mis en lumière par les soins de Vander-Bruggen* (Paris, 1689). "[Lafage] imaginoit d'abort ses sujets bien disposez et les executoit en mesme temps *sans aucune preparation*" [emphasis added].

2. Engraving by Caylus illustrated in Jeanne Arvengas, *Raymond Lafage, dessinateur* (Paris, 1965), 90 and fig. 17.

La Fage fecit L'Elevation de la croix

20. Attributed to Circle of Raymond Lafage
 Supplicants before an Emperor
 Last quarter of the 17th century

Pen and brown ink on heavy laid paper

35.5 × 51.4 (14 × 20)

Inscription: "Lafage" at bottom right in brown ink

The Suida-Manning Collection, 354.1999

Although originally attributed to Raymond Lafage, this drawing does not appear in either of the two catalogues of his works.[1] A comparison of the horse in the present sheet with the horse in the *Elevation of the Cross* (cat. 19) makes clear that the drawings are from different hands. The inscription "Lafage" in the lower right corner is not an autograph and likely by a later collector. There are some similarities, however, between this sheet and the drawing more firmly given to François Boitard (cat. 21). The hatching, with medium-length strokes on a diagonal, with unequal interstices and the treatment of anatomical details, such as the feet, may also signal the same hand. Similarly, there's a *horror vacui* in Boitard's drawings that is absent in Lafage's images. It has been suggested that this drawing is a copy after Lafage, but no model has been identified.

1. Nathan T. Whitman, *The Drawings of Raymond Lafage* (The Hague, 1963) and Robert Mesuret, *Les dessins de Raymond Lafage* (Toulouse, 1962).

21. François Boitard

c. 1670–1715 The Hague

The Continence of Scipio

c. 1710

Pen and brown ink on heavy laid paper

47 × 62.2 (18½ × 24½)

Inscriptions: "Boitard a [possibly] Le Crocq eu [possibly] fait trois quart D'heure" at bottom center in brown ink: "[illegible] Van den [or der] [illegible]" at bottom left in brown ink, obscured by borderline drawn through the text

The Suida-Manning Collection, 53.1999

Precious little is known about Boitard with the exception that he studied with Raymond Lafage and that he worked in London for several years after 1709.[1] His teacher's practice of dashing off compositional sketches of complicated subjects (cat. 19) clearly had an impact on Boitard: the inscription on the present sheet boasts that the large drawing was made "in three-quarters of an hour." Similarly, an anonymous drawing of a riot of musicians in the British Museum tentatively attributed to Boitard is inscribed "pour exprimer des pestes d'ignorans / je nay pas mis demi heure de tems" (in order to express damned idiots, I have not put [in] a half of an hour) in the lower right margin.[2] Clearly, time was of the essence for this artist.

Despite the throng of figures in the Blanton drawing, the overall effect is fairly thin and airy if energetic. Boitard drew his figures without repetitive strokes that signal correction or adjustments, concentrating the shorter dashes and dots to a horizontal band at the center of the sheet. The hatching is broad and even and limited to large masses at the periphery. Typical of other examples of his work,[3] the space here is shallow and ill defined.

The Continence of Scipio was a popular theme taken from ancient Roman history to allegorize magnanimity and generosity in victory. It shows the Roman general Scipio Africanus releasing a maiden, taken as a spoil, during his conquest of New Carthage in Spain.

1. Jane E. Kromm, "Hogarth's Madmen," *Journal of the Warburg and Courtauld Institutes* 48 (1985): 240. Kromm cites a print by Boitard of *The Pilgrim*, a performance of which is recorded in 1711 that was a precedent for Hogarth's scenes of madhouses.

2. BM1987.1012.3328. The subject of the drawing is identified as the rivalry between Christophe Willibald Gluck (1714–1787) and Niccolò Piccini (1728–1800). If this is so, then the drawing cannot be attributed to Boitard, who died before Piccini was born and when Gluck was still a child. I suggest that the brawl depicted in the drawing refers to some other incident in the history of music.

3. The British Museum has several signed and dated drawings of this type. See also *The Flood* in the Princeton University Art Museum.

22. Circle of Jean-Antoine Watteau

Landscape in a Roman Manner

c. 1715–1716

Red chalk on cream antique laid paper

29.4 × 44 (11⁹⁄₁₆ × 17⁵⁄₁₆)

Provenance: Spencer A. Samuels & Co., Ltd., New York.

Reference: BMA 2006, 78.

Archer M. Huntington Museum Fund, 1982.725

This work came into the collection as a Venetian landscape by Watteau. Its authorship is now uncertain, and even the subject has shifted from Venice to Rome. Over the last twenty years, Watteau's oeuvre has been studied and culled, with many works being reattributed to other artists.[1] Watteau never traveled to Italy, but he had access to a substantial collection of Venetian drawings owned by Pierre Crozat, his patron and benefactor. He made copies of works by Titian, Domenico Campagnola, and the Bassano family from that collection. No Venetian model for this drawing was ever found.

The mountainous background and the medieval, hilltop town crowned with asymmetrical towers signal Italian inspiration. The tree on the left and the rocky outcropping on the right are familiar framing devices for eighteenth-century landscapes. The artist has included none of the typical staffage (shepherds, fishermen, hunters, or peasants) in the composition. It is devoid of any cross-hatching, and the short curved strokes that articulate the foliage of the tree form a rhythmic pattern that evokes rustling leaves. The central focus of the composition is a rather unheroic cluster of trees isolated in the middle ground and blocking what would otherwise be a grand vista. It is an accomplished drawing and one well conceived and finished, even if by an unidentified artist.

1. Margaret Morgan Grasselli, "Following in Watteau's Line: Some Drawings by Jean-Baptiste Pater," *Master Drawings* 38, no. 2 (Summer 2000): 159–166. See also "Landscape Drawings by François Le Moyne: Some Old, Some New," by the same author in *Master Drawings* 34, no. 4 (Winter 1996): 365–374. Pierre Rosenberg and Antoine Prat, *Antoine Watteau, 1664–1721, catalogue raisonné de dessins* (Milan, 1996). Jolynn Edwards, "Watteau Drawings: Artful and Natural," in *Antoine Watteau: Perspectives on the Artist and the Culture of His Time* (Newark, DE, 2006), pp. 41–62.

23. François Le Moyne

Paris 1688–1737 Paris

Dido and Aeneas

c. 1721

Black and white chalks on blue antique laid paper, laid down

24 × 26 (9⁷⁄₁₆ × 10¼)

Inscriptions: "J.C.S." embossed at bottom right of mount; "F. LeMoine" on verso, at bottom left of mount in ink; on verso, in brown ink: "François le Moine / né à Paris en 1688. mort dans la meme ville en 1737. / Elève de Galoche. École française. / Il était premier peintre du Roi. Ses ouvrages ont de l'ame & de feu. / S'il était mou & incorrect dans le dessin & un peu maniéré dans les formes; / il plaisait par cette morbidesse qui charme le grand nombre des spectateurs, / bien plus qu'une savante & profonde etude. / Il crut qui son mérite était méconnu, & crut meme ses ennemis / a . . . [illegible] puissans pour lui ravir la liberté. Son esprit s'aliéna, & un matin que / Mr. Berger qui l'aimait, & qui l'avait conduit à Rome, venait le chercher pour / le mener à la campagne, où il espérait le faire traiter, il crut qu'on venait / pour le conduire en prison, se frappa de neuf coups d'epée, eut encore la force / d'ouvrir sa porte, & tomba mort aux pieds de son ami. / a / 1739 [possibly]

Provenance: J. C. Spengler (1767–1839) [Lugt 1434]; Spengler sale, 8 October 1839, Copenhagen; acquired in London.

Reference: Bordeaux 1984, 159.

Archer M. Huntington Museum Fund, 1984.77

A member of the Académie royale and named First Painter to King Louis XV, Le Moyne was criticized for his weak and inaccurate drawing as well as his mannerist forms. His redeeming quality, however, according to the lengthy inscription on the verso of the present sheet, lay in his languid grace (*morbidesse*). He is credited with transitioning from an entirely baroque style into the rococo, especially through his students Charles-Joseph Natoire (cats. 29–30) and François Boucher (cats. 31–32). Although Le Moyne won the Prix de Rome in 1711, he would not go to Italy until 1723, visiting Bologna and Venice on his way to Rome, under the aegis of his patron, the financier François Berger (1684–1747).

This drawing is highly finished but may have been conceived as a decoration—possibly for an overdoor, fire screen, or fan—or as a tapestry for a chair.

F. Le Moine.

24. Nicolas Lancret
 Paris 1690–1743 Paris
 Study of a Man
 1730s

 Black and white chalks on gray laid paper

 16.8 × 13.7 (6⅝ × 5⅜)

 Provenance: Julius Weitzner [photograph at Getty stamped "Julius Weitzner file"]; Robert Lee Manning (1924–1996).

 The Suida-Manning Collection, 357.1999

Lancret's work is typical of the rococo style and subject matter initiated by his older contemporary, Jean-Antoine Watteau (1648–1718). Like Watteau, Lancret studied with Claude Gillot (1673–1722) and offered as his *morceau de réception* (reception piece) for the Académie royale a painting of a *fête gallante*, a type of subject matter invented by the members of the academy especially for Watteau. These light-hearted, elegant, outdoor amusements were immensely popular among the aristocracy and wealthy merchants. Lancret counted Louis XV and Frederick the Great among his patrons.

The present drawing may be a figure study for one of the dancers in the painting *Dance around the Tree* in Dresden (fig. 1).[1] The male figure, now partially obscured by the tree and a female dancer in the foreground, is standing in a position that corresponds with the Blanton sheet. The male dancer in the right foreground, seen from behind, is essentially a mirror image of the Blanton figure study. According to Mary Tavener Holmes, it was not uncommon for Lancret to produce such studies, despite their eventual obliteration in the final paintings.

A close friend of François Le Moyne (cat. 23) and a collector of both old master works and those of his more conventional contemporaries, such as Charles-Joseph Natoire (cats. 29–30), Lancret was regarded as a talented and sensitive draftsman. He was more firm in his handling of the chalk than was Watteau, and therefore his drawings convey both solidity and energy.

1. I want to thank Mary Tavener Holmes for identifying this painting and proposing this relationship.

Fig. 1. Nicolas Lancret, *Dance around the Tree*, oil on canvas, 43 × 53 cm, Gemäldegalerie Alte Meister Staatliche Kunstsammlungen, Dresden.

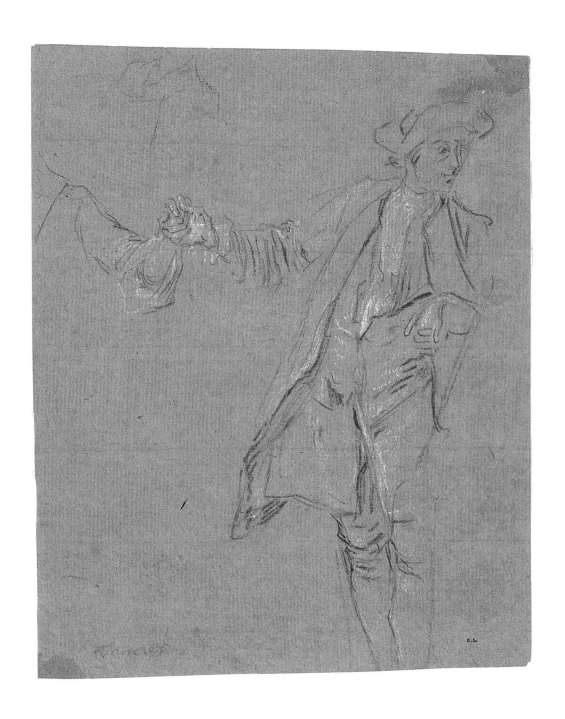

25. Charles-Antoine Coypel

Paris 1694–1752 Paris

France Thanking Heaven for the Recovery of Louis XV

1744

Black and white chalks with brush and gray wash and touches of red chalk on cream antique laid paper

30.3 × 20 (11^{15}⁄$_{16}$ × 7⁷⁄₈)

Watermark: possibly MGIS

References: Cremona 2001, 182–183; BMA 1999, 43; Lefrançois 1994, 328–330 and 454–455; Ontario 1972, 150–151.

The Suida-Manning Collection, 191.1999

Unlike most of the artists in the official ranks, Coypel did not travel to Italy to study antiquity and Renaissance masters. Coming from a family of artists and studying with his father Antoine (1661–1722), Coypel was admitted to the academy in 1715 and appointed First Painter to King Louis XV in 1747. Early in his career, Coypel was equally interested in the theater as in art, writing several plays of which none were ever performed. Discouraged by this rejection, he turned back to painting, where his style became increasingly theatrical. In 1751, the year before he died, he published a treatise, *Le Parallèle de l'eloquence et de la peinture*, extending the discussion begun by Charles Le Brun with his theories published in *Méthode pour apprendre à dessiner les passions proposée dans une conférence sur l'expression générale et particulière* (Amsterdam and Paris, 1698).

The Blanton drawing is preparatory to a painting the artist produced on the occasion of Louis XV's recovery from what was thought to be a fatal illness in 1744 during a trip to Metz. Coypel gave the unsolicited painting to the queen, Marie Leczinska, who had it hung in her chambers at Versailles.[1] The Rubenesque figure of France in the drawing exemplifies the expressive qualities Coypel later advocated in his treatise and is derived from his earlier interpretation of Molière and Corneille's *Psyché*.

1. The painting was given in 1808 to the church at Clairvaux, where it remains. A pastel of the same subject, only slightly modified, is in the Musée du Louvre, Paris. An engraving after the painting was made by Pierre-Louis Surugue (1717–1771) and exhibited in the Salon of 1745.

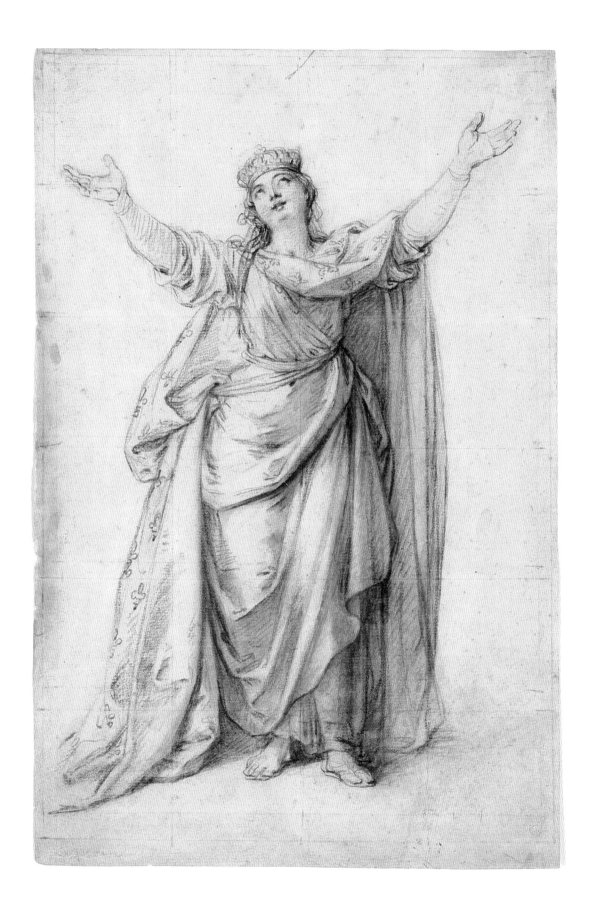

26. Étienne Parrocel
 Avignon 1696–1776 Rome
 Personification of Justice
 Middle of the 18th century

Black and white chalks on beige antique laid paper

51.6 × 39.5 (20⁵⁄₁₆ × 15⁹⁄₁₆)

Inscriptions: "Pompeo Battoni 1702–1787" at bottom center in graphite; "JGM" at bottom right in graphite

References: Cremona 2001, 186–187; BMA 1999, 47.

The Suida-Manning Collection, 437.1999

Étienne Parrocel, called "le Romain," came from a long line of artists and traveled in 1717 with his uncle to Rome, where he spent the rest of his life. He was a prolific painter and draftsman, focusing largely on altarpieces. Among his few allegorical works is a decorative ceiling panel of Philology for the library of the Palazzo Corsini in Rome of 1747.[1]

Although this grand sheet is one of the rare examples of a secular subject by this artist, it is typical of the baroque classicism influenced by Carlo Maratta (1625–1713) that Parrocel practiced.

Mistaken by an earlier collector for a drawing by Pompeo Batoni (1708–1787), the work is nevertheless characteristically French. Its geometric handling of volume, solidity of form, hatching, emphatic contours, and treatment of drapery folds as pattern carry on the tradition begun by Charles Le Brun and Jean Jouvenet (cat. 16). The placement of the figure on the sheet and the variation of details in the corners are similar to drawings more firmly attributed to Parrocel.[2] Probably more than any of the other works in this catalogue, Parrocel's *Justice* represents the hybridization of French Italianate draftsmanship.

1. For an illustration, see Enzo Borsellino, "Il Cardinale Neri Corsini Mecenate e Committente Guglielmi, Parrocel, Conca e Meucci nella Biblioteca Corsiniana," *Bollettino d'arte Roma* 66, no. 10 (1981): 54.

2. See *Madonna and Child* (Sotheby's, London) illustrated in Giorgio Falcidia, "Stefano Parrocel in Monticelli e Altrove," *Bollettino d'arte* 77, no. 65 (1991): 135.

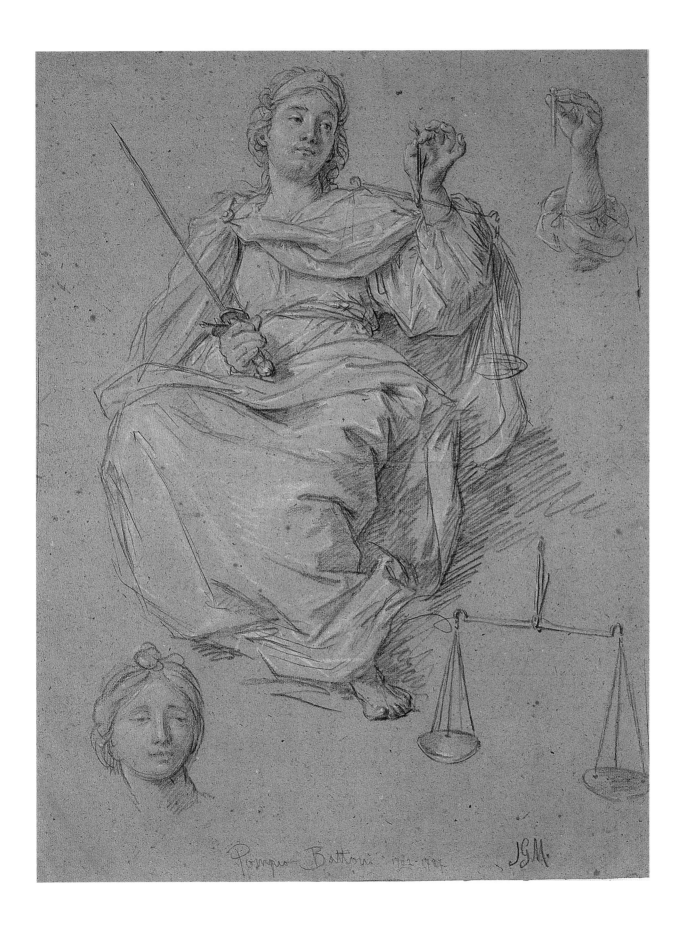

Pompeo Battoni 1702-1787 JGM

27. Attributed to Étienne Jeaurat

Paris 1699–1789 Versailles

Three Women, Two with Baskets

c. 1770

Black and white chalk on gray laid paper

18.4 × 22.9 (7¼ × 9)

Inscription: "PC" monogram [Lugt 2073] stamped at bottom left in black ink

Provenance: Philippe de Chennevières.

The Suida-Manning Collection, 342.1999

Despite having studied in Rome with Nicolas Vleughels (1668–1737), Jeaurat exhibited very few Italianate traits in his art. The broken contours, fractured modeling of tones, heavy proportions, and stern facial expressions characteristic of his work communicate a coarseness not seen in drawings by his contemporaries, such as Nicolas Lancret (cat. 24) and Charles-Joseph Natoire (cats. 29–30). Jeaurat was recognized as a history painter, but his oeuvre is replete with genre scenes, particularly those of street views and outdoor markets. Most of Jeaurat's figure studies can be definitively linked to finished paintings. This sheet, however, does not have an obvious corollary.

The collector's stamp at the bottom of the drawing tells us it once belonged to Philippe de Chennevières (1820–1899), a very important figure in arts administration in France during the second half of the nineteenth century. Over the course of his long career, Chennevières held various curatorial positions both in Paris and the provinces; for a period in the 1850s, he was responsible for organizing the official Salons. From 1873 until 1878, he served as director of the fine arts. He was a prolific writer, and he amassed an impressive collection of drawings that he meticulously catalogued, loaned to exhibitions, and made available to artists and connoisseurs who visited him. Chennevières described two drawings of three female figure studies by Edme Jeaurat—Étienne's older brother, who was better known as a printmaker and publisher.[1] Chennevières relates that one of the studies shows women holding paper, which eliminates the drawing from consideration here. The second is described simply as a study for the painting *La place Maubert*;[2] however, there is no figure in the painting that even remotely corresponds with those in the Blanton drawing. Is the sheet in Austin a different, unrecorded work altogether? Or did Chennevières misidentify both the artist and the painting to which it related?

The figure on the far left of the Blanton sheet does appear in slight variation in two works by Étienne Jeaurat. A painting on the Paris art market in 1965[3] showing the entrance to a village with peasants and shoppers carrying poultry, produce, and baskets is signed and dated 1770; the image features a woman standing in profile, facing right, with a basket. This figure is repeated exactly in *La retour du marché*,[4] which was executed as a tapestry around 1775 by the Gobelins manufactory after a design by the artist. The female figure in profile in the Blanton drawing may be an earlier version of Jeaurat's character, suggesting a date of circa 1770.

1. Louis-Antoine Prat, *La collection Chennevières: Quatre siècles de dessins français* (Paris: Musée du Louvre Éditions, 2007), 185 and 500, catalogue no. 1102.

2. Now in the Musée Carnavalet in Paris and reproduced in 1753 by Jean-Jacques Aliamet (1726–1788).

3. Location unknown; Getty photo study collection, Palais Galliera, 29 November–3 December 1965.

4. Location unknown; Getty photo study collection.

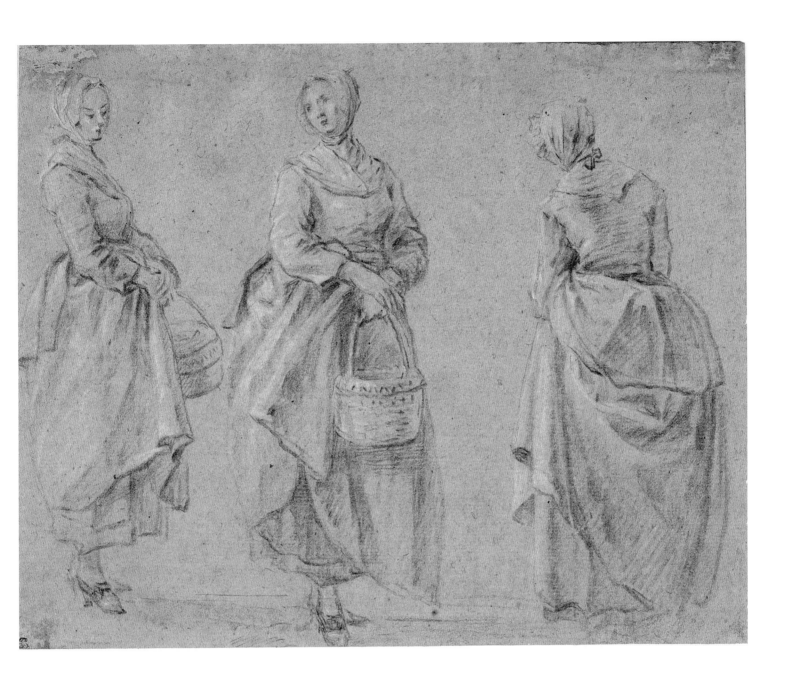

28. Attributed to Hubert-François Gravelot

Paris 1699–1773 Paris

Illustration for Pierre Corneille's *Polyeucte*

c. 1764

Pen and brown ink and wash on laid paper

17 × 10.5 (6¹¹⁄₁₆ × 4⅛)

Inscription: "Qu'on me mene a La mort." at bottom center in brown ink

Gift of Dr. and Mrs. Glen D. McCreless, 2009.3

Book illustration in England and France benefited greatly from Gravelot's contributions to what had been a relatively minor genre. His attempts to travel to Rome were thwarted when he ran out of money on his way there, thus forcing him to return to Paris. After studying with Jean Restout II (1692–1768) and later François Boucher (cats. 31–32), Gravelot went to London in 1732 at the invitation of a publisher who needed help with engravings for his books. There he established his reputation as the leading illustrator of a generation and taught drawing at St. Martin's Lane Academy. In 1745, he returned to Paris, where his skills were in high demand. Voltaire sought the artist's talents for his 1764 illustrated edition of Corneille's plays, to which the present drawing is related.

Gravelot was a prolific draftsman, and the myriad drawings he left allow for a thorough analysis of his working methods.[1] A complete set of thirty-four finished drawings for Voltaire's edition remains intact in a private collection in Switzerland.[2] Several of the preliminary drawings related to *Polyeucte* have been on the art market over the last twenty years, but their current locations are unknown, preventing a reconstruction of this particular sequence.[3] From other cases, however, where the drawings are held in public museums,[4] scholars have determined that Gravelot worked out the compositions and figures first in the nude and then added drapery in later sketches. Once he arrived at the final composition, he produced a highly detailed and precise line drawing and a second wash drawing, indicating tonalities. He turned both over to the engraver, in this case Louis L'empereur (1728–1807), for translation of the drawing into a print (fig. 1). It has also been suggested that Gravelot produced "deluxe" drawings after some of his prints for certain clients. In all, there could be between three and eight drawings related to each of his printed illustrations.

The present sheet falls between the very sketchy preliminary studies and the final versions. The unfinished decorative medallion against the back wall and the cursory treatment of some of the details, combined with the handwritten inscription identifying the subject, raises questions about the attribution. When Gravelot included the inscriptions at the bottoms of his drawings, he did so meticulously with painstaking precision simulating letterpress. This could argue for a student copy after the master's finished engraving, since it is not reversed. There are occasions, however, when Gravelot drew the composition in the same orientation as he intended the print, and the handwritten inscription could be that of a collector. The facility with the proportions of the anatomy and the handling of the ink support a tentative attribution to Gravelot.

1. Kimerly Rorschach, *Eighteenth-century French Book Illustration: Drawings by Fragonard and Gravelot from the Rosenbach Museum and Library* (Philadelphia, 1985). Philip Hofer, "Preliminary Sketches for Gravelot's *Corneille*," *Harvard Library Bulletin* (1951): 197–208.

2. Christie's sale 8196, 19 May 1995, lot 154.

3. Hôtel Drouot sale, Paris, December 10, 1997, lot 31B.

4. Ruth Kramer, "Drawings by Gravelot in the Morgan Library," *Master Drawings* 20 (Spring 1982): 3–21.

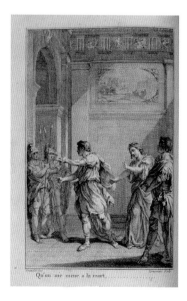

Fig. 1. Louis L'empereur, Illustration for Pierre Corneille's *Polyeucte*, after Gravelot, 1764. Photo courtesy of the Harry Ransom Center, The University of Texas at Austin.

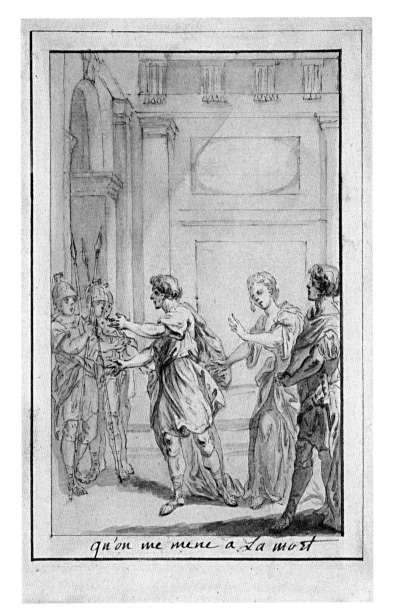

qu'on me mene a La mort

29. Charles-Joseph Natoire

Nîmes 1700–1777 Castel Gandolfo

Neptune and Amphitrite

C. 1730S

Black chalk with brush and brown wash and white heightening on blue laid paper

24 × 37 (9⁷⁄₁₆ × 14⁹⁄₁₆)

Inscription: signed "Ch. Natoire" at bottom left in brown ink

References: AFA 1966, 13; BMA 1999, 45.

The Suida-Manning Collection, 404.1999

A thorough and insightful study of Natoire's drawings has identified three distinct categories of his production.[1] His student years in Rome (1724–28) yielded the typical copies after masters, usually in red chalk. His time in Paris and friendship with Pierre-Jean Mariette (1694–1774), who commissioned copies of Italian drawings from him, allowed the artist to develop a more sophisticated dialogue with the past. Finally, his directorship of the Académie de France in Rome led him to focus on drawing as a pedagogical tool.

Although it has been proposed that this sheet was drawn at the beginning of his directorship of the academy (1751–1775), it bears much resemblance to his drawings of the 1730s and 1740s while he was still in Paris. The combination of media is characteristic of this period, and the figures and composition are redolent of the limpid style of François Le Moyne (cat. 23), under whom Natoire studied. Moreover, Natoire sent a painting, *Amphitrite sur les eaux*, to the Salon of 1737 that is stylistically, though not compositionally, similar to the present drawing.

1. Perrin Stein, "Copies and Retouched Drawings by Charles-Joseph Natoire," *Master Drawings* 38, no. 2 (Summer 2000): 167–186.

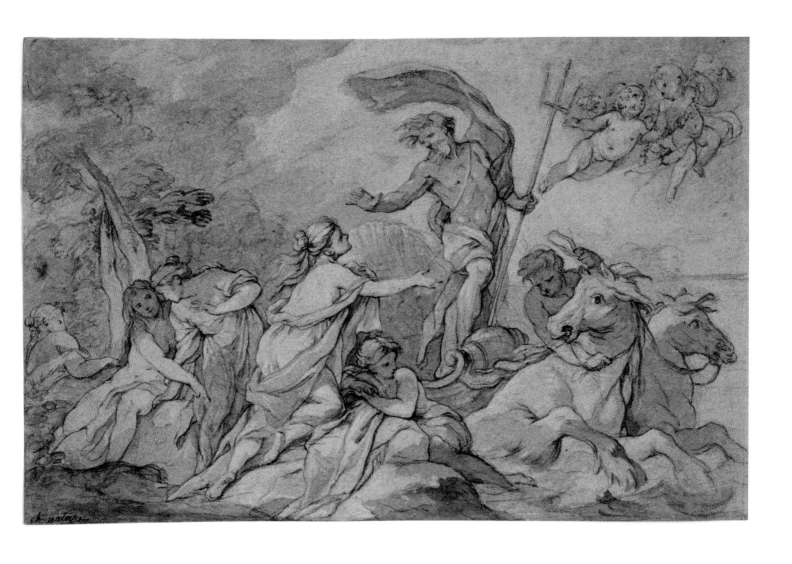

30. Charles-Joseph Natoire

Nîmes 1700–1777 Castel Gandolfo

Venus and Cupid

1755

Black and white chalk with stumping on blue laid paper

24 × 37 (9⁷⁄₁₆ × 14⁹⁄₁₆)

Inscription: signed and dated "Natoire / f. Roma 1755" at bottom right in iron gall ink

The Suida-Manning Collection, 405.1999

Signed and dated 1755, the present work is a prime example of Natoire's second Roman period. By this time, he had shed most of the languid treatment of anatomy he learned from his master, François Le Moyne (cat. 23). His figure types are full-faced, graceful, and ample without being exaggerated. Compositional transitions are subtle, made with extensive use of the stump to soften contours and modulate tone from one plane to another. The white chalk used as a highlight is applied thinly and fairly evenly over the figure of Venus as an additional means of modeling rather than in sharp, thin lines used to pick out drapery folds (cf. Jouvenet, cat. 16, or Lancret, cat. 24). Although Natoire treated the subject of the education of Cupid, as this was once called, on several occasions, this drawing is an autonomous, finished work unrelated to any other.

As the director of the Académie de France in Rome from 1751 until 1775, Natoire had a significant impact on the development and education of a generation of artists, chief among them Jean-Baptiste-Marie Pierre (1713–1789) (cat. 33), Joseph-Marie Vien (1716–1809), Hubert Robert (1733–1808), and Honoré Fragonard (1732–1806) (cat. 37). In his correspondence from Rome to his superiors in Paris, Natoire expressed significant misgivings over drawing pedagogy within the academy, but his attempts at reform proved unsuccessful.[1] Like Verdier before him, Natoire produced a suite of *académies* intended as models for his students.[2]

1. Pierre Rosenberg, "Natoire Directeur de l'Académie de France à Rome," in *Charles-Joseph Natoire, peintures, dessins, estampes et tapisseries des collections publiques françaises* (Troyes, 1977), p. 27.

2. Jacques-Jean Pasquier, *Livre d'Academies par Charles Natoire* (Paris: Huquier, 1745).

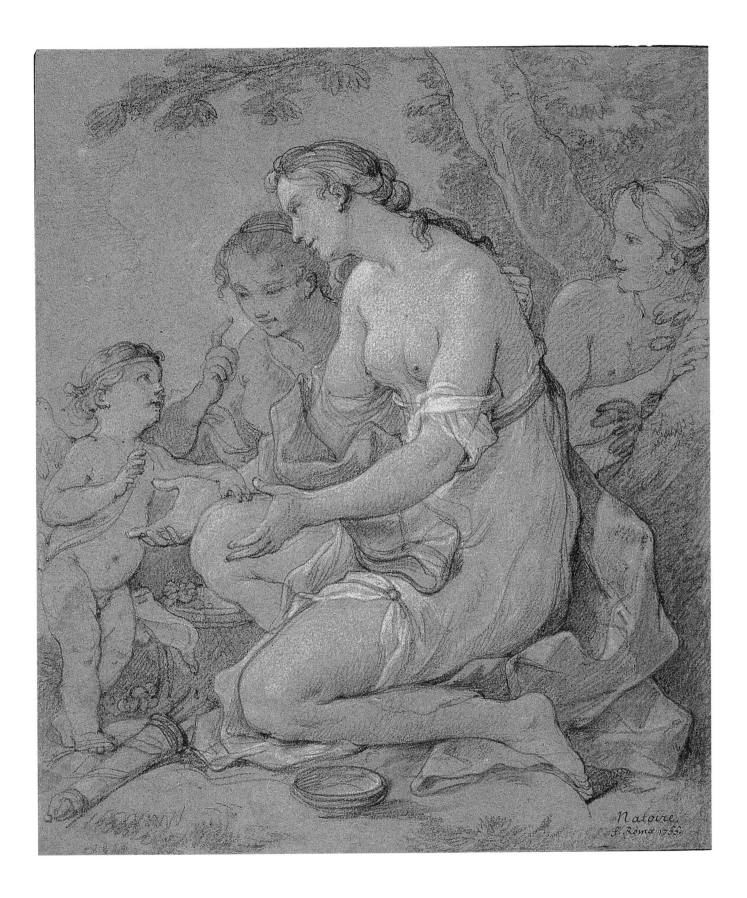

31. François Boucher

Paris 1703–1770 Paris

Mucius Scaevola Putting His Hand in the Fire

c. 1726–1728

Black and white chalks on blue antique laid paper, laid down

46.7 × 38 (18⅜ × 14¹⁵⁄₁₆)

References: Michel 1906, possibly Catalogue no. 883; NGA 1973, 3; Jacoby 1986, 67 and 237; MMA 1986, 109, fig. 84; Matthiesen 1987, Catalogue no. 5; BMA 1999, 43; Cremona 2001, 184–185; AFA 2003, 50–51; BMA 2006, 92.

The Suida-Manning Collection, 60.1999

Mucius Scaevola was the Roman hero who won freedom and peace for his people from the Etruscans by placing his right hand into a fire, thereby proving his bravery and endurance. That Boucher depicts the Roman general's left hand in the flame suggests this drawing was made from a related oil sketch (Musée Sandelin, Saint-Omer) in preparation for a print that was never executed.[1] Alastair Laing argues, however, that the Blanton drawing is too sketchy to transfer to a plate for engraving and notes that the protagonist still holds his sword in his right hand, whereas the oil sketch shows a dagger—not a sword—on the ground.[2] Laing concludes that Boucher made the oil sketch in part to correct the erroneous details in the drawing. As no finished painting of this subject survives from Boucher's oeuvre, the question of the function of the drawing (and the oil sketch) remains. Laing offers that Boucher may have made them as demonstration pieces to take with him on his trip to Italy in 1728 in the hope of securing patrons who would fund his study there. Boucher's use of blue paper for the drawing might also support that notion, as there is no practical advantage in choosing it for the transfer process.

Like Charles-Joseph Natoire (cats. 29–30), Boucher was a pupil of François Le Moyne (cat. 23); his early work, such as the present sheet, shows some influence from the elder artist. Boucher brilliantly captures the drama and tension of the story in his fluid and sinuous figures that spill from the center of the composition anchored by the burning altar.

1. Bober in BMA 1999, 43.

2. AFA 2003, 51.

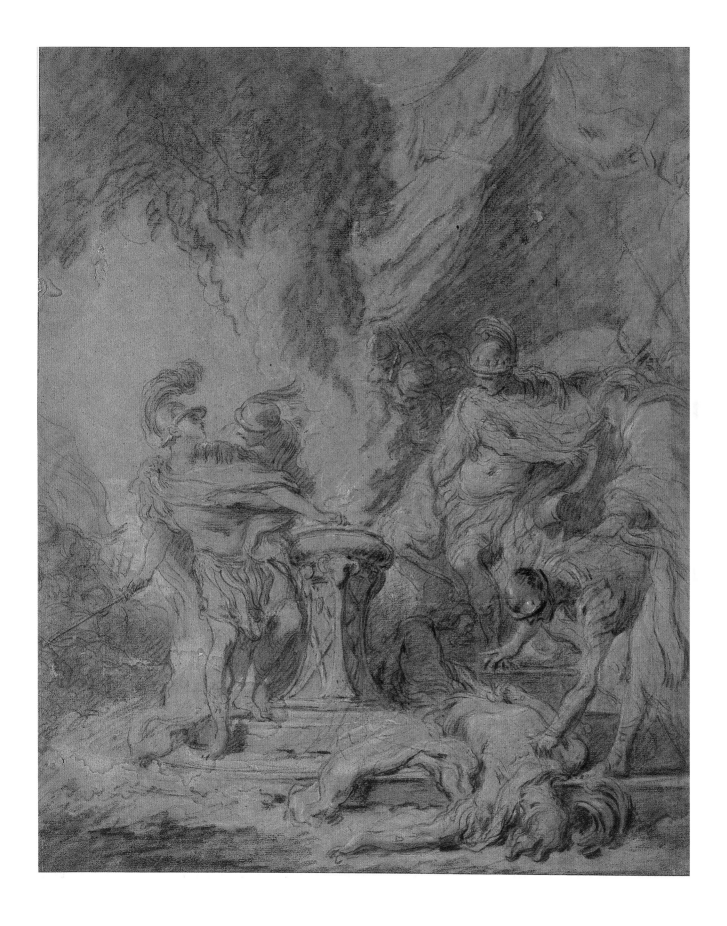

32. François Boucher

Paris 1703–1770 Paris

Juno Commanding Aeolus to Unleash the Winds

1769

Black chalk on cream antique laid paper

22.5 × 29.9 (8⅞ × 11¾)

Watermark: "IV" at top right [possibly initials of Jean Villedary Per Churchill, 57.]

References: San Antonio 1995, fig. 109; Clark 1998, 230, fig. 2.

Provenance: A. Mos and Dr. J. Nieuwenhuizen Collection sale, R. W. P. de Vries, Amsterdam, 2 November 1928, lot 117; Christie's, London, 6 July 1977, lot 93 [sold for £7000]; possibly Mr. Morrison; Spencer A. Samuels & Co., Ltd., New York, before 1981.

Archer M. Huntington Museum Fund, 1982.724

Boucher's years in Italy (1728–1731) were spent copying the works of Bernini, Giovanni Battista Gaulli, Luca Giordano, and Castiglione rather than those of Renaissance masters Michelangelo and Raphael. After returning to Paris, Boucher was received into the Académie royale and earned a comfortable living from his cabinet pictures, becoming the favorite painter of Madame de Pompadour, King Louis XV's mistress. He was named First Painter to the King and director of the academy in 1765.

This drawing is among the earliest in a series of studies related to a painting made late in the artist's prolific career, now at the Kimbell Art Museum in Fort Worth. Alvin Clark and Alastair Laing have each added drawings to the sequence and proposed a chronology for them, which need not be reviewed here.[1] A residue of Boucher's Italian models remains in a composition dense and dynamic with bulky forms that elide and tumble out of the picture plane. The rocky landscape pulsates with the same vigor as the nymphs. His handling of the figures is bold and sure, perhaps formulaic. Critics bitterly complained that in his maturity Boucher, like many other artists his age, had abandoned looking at nature or using a model; rather he worked by rote.[2] By the nineteenth century, though, the Goncourt brothers restored Boucher's reputation, citing specifically his drawings. "What made Boucher popular no less than his paintings were his drawings," they wrote, stating erroneously that he was the first to recognize the commercial value of his own drawings.[3]

1. Clark 1998, 230–231; AFA 2003, 196–197.

2. Denis Diderot, *Diderot on Art*, trans. John Goodman, vol. 1 (New Haven, 1995), 24.

3. "Ce qui popularisa Boucher non moins que ses tableaux, ce furentses dessins. . . . Boucher fut le premier qui fit du dessin une branche de commerce pour l'artiste, qui le lança dans la publicité, qui appela sur lui l'argent, le gout et la mode." Edmond & Jules de Goncourt, *L'Art du dix-huitième siècle* (Paris, 1880), 149.

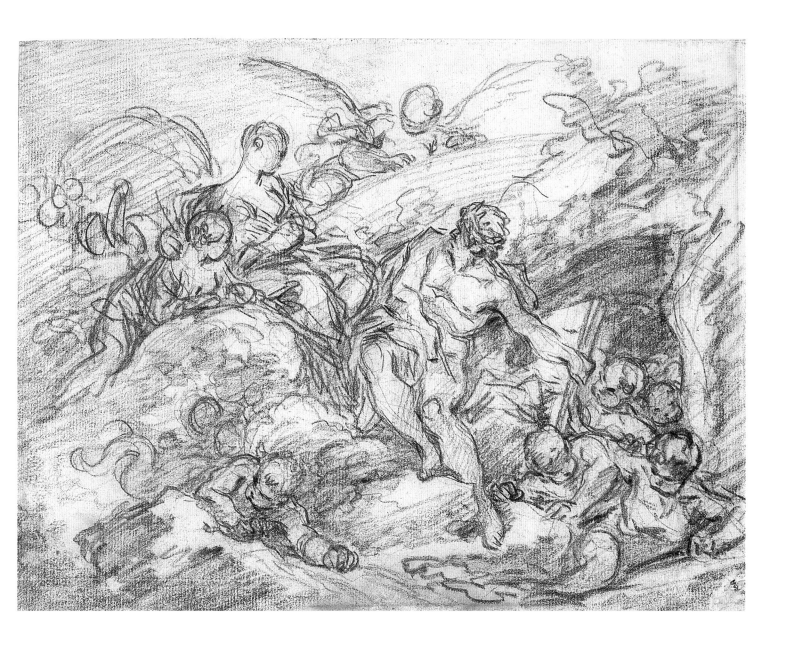

89

33. Jean-Baptiste-Marie Pierre

Paris 1713–1789 Paris

The Rest on the Flight into Egypt

c. 1740s–1750s

Pen and black ink and gray wash on paper, laid down

16 × 21.6 (6⁵⁄₁₆ × 8½)

Inscriptions: "Pierre" at bottom right in brown ink; "No. 629" at bottom right of mount in graphite; "CPL" [Lugt 622] stamped in black at bottom center of mount; "Cabinet Prince de Ligne" on verso, at bottom right in graphite

Provenance: possibly Prince de Ligne.

References: Ontario 1972, 82 and 195.

The Suida-Manning Collection, 457.1999

A student of Charles-Joseph Natoire (cats. 29–30), Pierre adopted a more classicizing style than that of his rival François Boucher (cats. 31–32), and Pierre's drawings were generally more highly regarded than his paintings. Denis Diderot, who frequently abused Pierre in his essays after 1759, admitted in his *Salon de 1767*, "he draws well, if dryly."[1]

Pierre treated the present subject in a painting (Musée des Beaux-Arts, Rouen) exhibited at the Salon of 1761 and related to a drawing now in the Musée des Beaux-Arts de Saint-Étienne.[2] The Blanton example is an unrelated and autonomous work full of charm, animation, and wit that epitomizes the spirit of the age and explains Pierre's success. An ostensibly serious religious subject becomes in Pierre's hands a lively and intimate domestic scene with the Virgin playing with the Christ Child while Joseph naps in the foreground. The braying donkey at right and the swaying evergreen at left provide further levity, making this a desirable sheet for a private collector.

The figures are solid and geometric, and the bold application of wash reveals an artist of considerable skill and confidence. Pierre enjoyed the patronage of the royal family, among others, and was named First Painter to King Louis XV in 1770 after Boucher's death, and director of the Académie royale. As a testament to the artist's accomplishments, the *Cahier de principes de dessin d'après nature* (*Notebook on the Principles of Drawing after Nature*), a multivolume manual on drawing published in three editions between 1773 and 1780, was dedicated to Pierre.

1. Denis Diderot, *Diderot on Art*, trans. John Goodman, vol. 2 (New Haven, 1995), 299.

2. Olivier Aaron, *Jean-Baptiste Marie Pierre, 1714–1789* (Paris, 1992), 18.

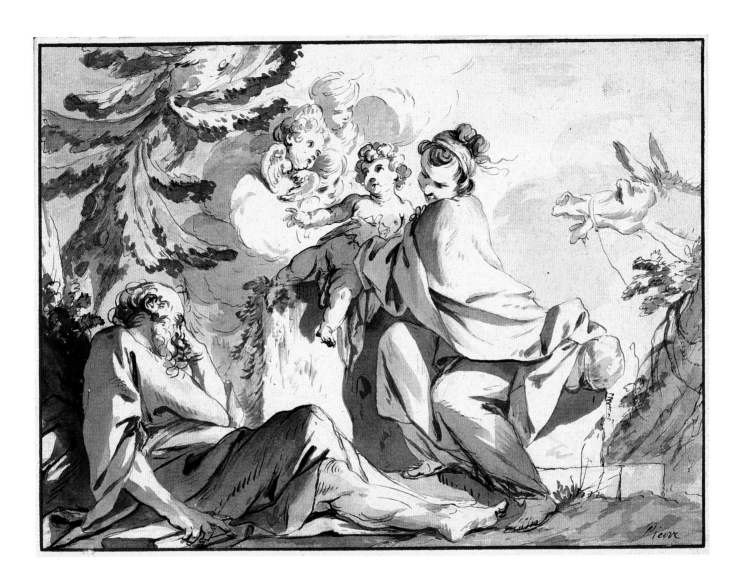

34. Jean-Baptiste Greuze
 Tournus 1725–1805 Paris
 The Arms of a Girl Holding a Bird
 c. 1765

 Red chalk on cream laid paper, laid down
 31.9 × 27.3 (12⁹⁄₁₆ × 10¾)
 References: BMA 1999, 43; Munhall 2002, 62.
 The Suida-Manning Collection, 309.1999

The *tête d'expression* (expressive head) was Charles Le Brun's codification of facial expressions intended to communicate basic emotions—fear, anger, sadness, happiness—that could be used in creating a narrative in painting or sculpture. Hands and gestures became equally as important in storytelling, and critics and connoisseurs took notice. In his *Salon of 1765*, Denis Diderot spun Greuze's painting *Young Girl Crying over her Dead Bird* into an allegory of betrayal and love lost. In his essay on this work, Diderot took special note of the subject's hands, commenting that they were made from a model other than the one Greuze had used for the face.[1] In the description of another painting, *Portrait of Madame Greuze with Child*, Diderot calls the sitter's hands "enchanting" although the "left one doesn't fully cohere."[2]

Greuze painted many scenes of young girls holding birds, but this sketch is not definitively linked to any of them.[3] The degree of finish, the certainty of the contours, and the placement in the center of the page suggest that this drawing may have been made for the market. The hand is gently cupped to cradle the bird, the fingers delicately arched as they lightly stroke the feathers. This sheet is a portrait of tenderness just as effective as a *tête d'expression*, and it brings to mind Albrecht Dürer's iconic study of praying hands.

1. Denis Diderot, *Diderot on Art*, trans. John Goodman, vol. 1 (New Haven, 1995), 102.

2. Ibid., 103.

3. Munhall 2002, 62.

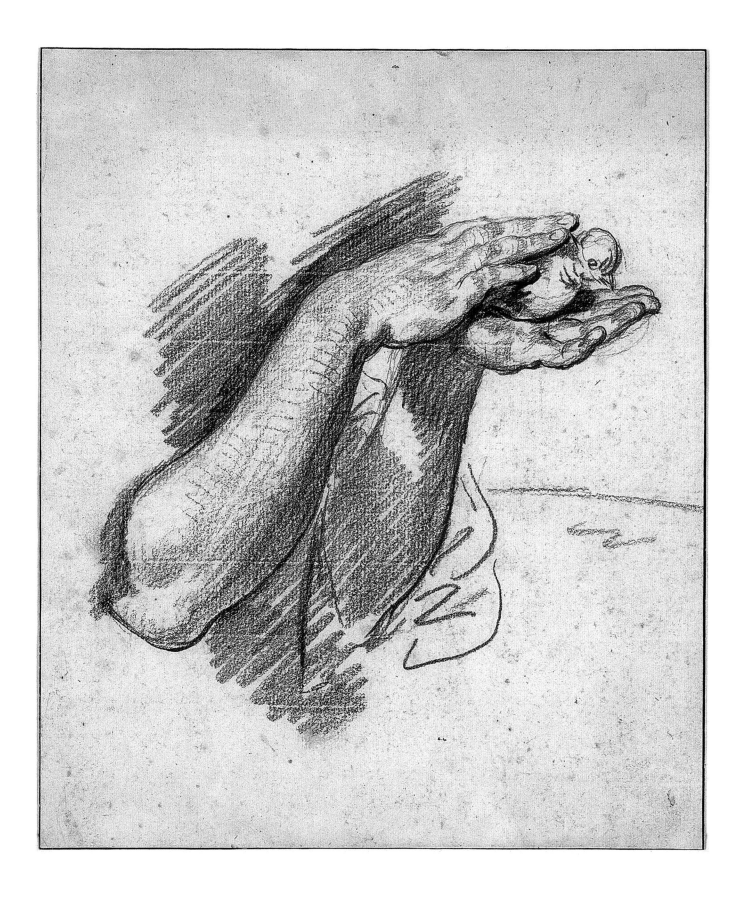

93

35. Jean-Baptiste Pillement
 Lyon 1728–1808 Lyon
 A Fantastic Flowering Branch
 c. 1760

 Black chalk on heavy, cream laid paper

 25.4 × 33 (10 × 13)

 Watermark: Bottom portion of fleur-de-lys in a shield with "[possibly]L V [possibly]G" below; cf. Heawood 1743 (c. 1761)

 Inscription: Signed "jean Pillement" at bottom right in ink

 The Suida-Manning Collection, 458.1999

Pillement was born in Lyon, the capital of the silk trade in France. He was initially trained by his father and uncle to paint flowers for use in the textile industry. Later, he took more formal instruction from French artist Daniel Sarrabat (1666–1748), who happened to pass through the city and decided to stay. At age 15, Pillement went to Paris and completed his artistic education at the Gobelins manufactory. He was a prolific artist and extremely popular. He traveled extensively to England, Spain, Portugal, Italy, Austria, and Poland, earning the title of First Painter to the King of Poland in 1767. Marie Antoinette gave him an annual stipend and named him Painter to the Queen in 1778.

His designs were printed and collected into pattern books used throughout Europe by textile manufacturers and decorators. The present sheet is one example of this type. It was printed by Pierre-Charles Canot (1710–1777) as part of a suite of eight fantastic floral designs in the Chinese taste and published in 1760 during his first sojourn in England.[1] Whimsical and imaginative, delicate and sensual, this image is the epitome of the rococo style so favored by the courts of Europe and all the fashionable houses of the time. Despite the seeming fragility of these botanical improbabilities, the drawing is confident. The fine, nuanced modeling is achieved by careful stumping. The broken contours, asymmetrical handling of mass, and rhythm of tonal variation achieve a quivering effect that would have brightened and enlivened any interior.

1. D. Guilmard, *Les Maitres ornemanistes* vol. I, p. 189 (Londre, 1760). #17 Une suite de huit pieces y compris le titre: *Recueil de differentes fleurs de fantaisie dans le gout chinois, propres au manufactures d'etoffes de soie et d'indienne, inv. et des. par Jean Pillement, gravé par P.C. Canot.* [17 A suite of eight pieces with the title: Gathering of different fantastical flowers in the Chinese taste, suitable for the manufacture of printed silk fabric, invented and designed by Jean Pillement, engraved by P.C. Canot.]

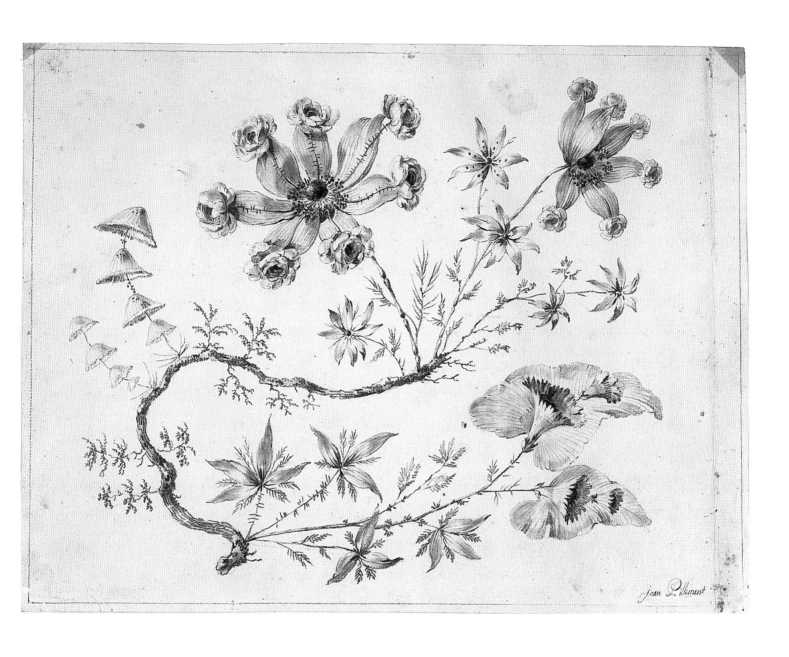

jean Pilliment

36. Jean-Baptiste Pillement
 Lyon 1728–1808 Lyon
 River Landscapes
 1760s

Black chalk on laid paper; one laid down on card

17.2 × 22.9 (6¾ × 9)

Provenance: The Princes of Liechtenstein; P. & D. Colnaghi and Co., London (per Sotheby's appraisal).

The Suida-Manning Collection, 459.1999 and 654.1999

Pillement's reputation was built on his work as a designer, but he was equally admired for his landscapes that combined both Dutch and Italianate influences. Though charming, these images are formulaic. The present sheets are typical of his style and comparable to similar drawings dated between 1762 and 1771.[1] Compositions are generally diagonal, often starting with a bold foreground in the lower left corner and moving upward to the right of the picture plane. A central motif—here a rustic house and an outcropping of trees—is pushed into the distance by the palest of tonalities and the most delicate of strokes. Scenes are often populated with doll-like shepherdesses, peasant travelers with backpacks and walking sticks, fishermen, goats, and sheep usually viewed from the back. The pilings that frequently appear are a witty reference to the artist's name.

It has been suggested that the artist was more likely to date a work after he had been named First Painter to the King of Poland in 1767.[2] In the mid-1770s, Pillement began to produce fewer of his decorative designs and focused almost exclusively on landscapes.[3] A change in the later drawings is detected, however, in the handling of the masses and a more static, frieze-like, and planar organization of the composition than those of works produced early in his career.

1. See *Jean Pillement: Paysagiste du XVIIIe siècle (1728–1808)* (Béziers, 2003), 39–40.

2. Marie Gordon-Smith, *Pillement* (Cracow, 2006), 99.

3. Nuno Saldanha and Agostinho Araújo, *Jean Pillement, 1728–1808, and Landscape Painting in 18th-Century Portugal* (Lisbon, 1997), 57.

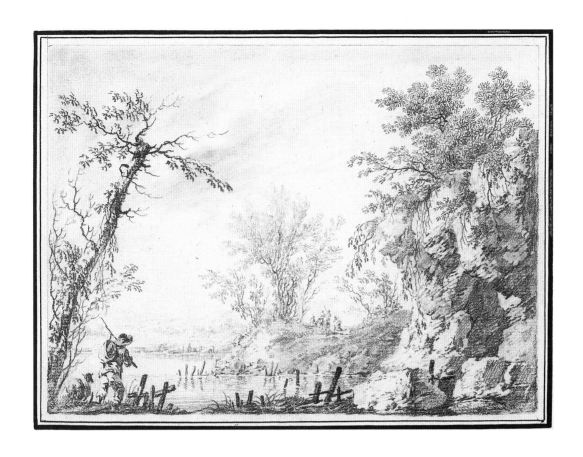

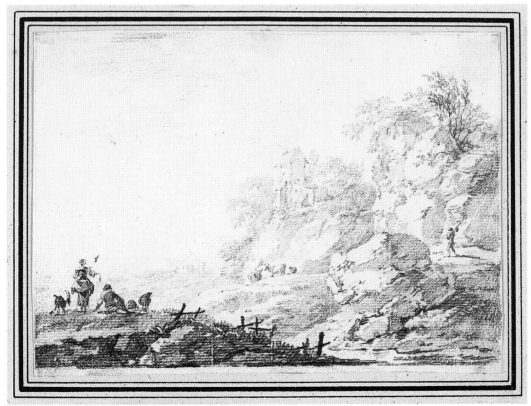

37. Jean-Honoré Fragonard

Grasse 1732–1806 Paris

The Reconciliation of the Romans and Sabines

1773 (after Rubens)

Brown wash and black chalk on antique laid paper

29.2 × 43.8 (11½ × 17¼)

Watermark: D & C BLAUW [Churchill 168 or 255]

References: McGrath 1997, 224 [as location unknown];
Raux 2007, 19.

Provenance: A. Paillet, Catalogue de tableaux des trois écoles par les plus grands maîtres anciens et modernes. . . 23 May 1780 . . . à l'hôtel de Bullion, Paris. No. 112 "Un Dessin lavé au bistre sur papier blanc, par Fragonard d'après P. P. Rubens; il represente *l'Enlèvement des Sabines*; no. 113: "Un autre Dessin, comme le precedent, par le même, representant un *Combat entre les Romains & les Sabines.*" ["No. 112: A wash drawing in bistre on white paper by Fragonard after P. P. Rubens; it shows *The Rape of the Sabines*; no. 113: Another drawing, like the previous one, by the same [artist] showing a *Battle between the Romans and the Sabines.*"].

The Suida-Manning Collection, 270.1999

Although he was awarded the Grand Prix de Rome in 1752, Fragonard did not make the trip until 1756 and then stayed an extra year until 1761. Charles-Joseph Natoire (cats. 29–30) was director of the Académie de France then and reported that upon Fragonard's arrival, he, among other students, was occupied in making drawings after Carracci's frescoes at the Palazzo Farnese. In addition to the standard examples of antiquity and Michelangelo, Fragonard spent a good deal of time copying the works of Luca Giordano, Paolo Veronese, Benedetto Castiglione, and Guido Reni.[1] For his official *envoi* to be sent back to Paris to assess the student's progress, Natoire assigned Fragonard to copy Pietro da Cortona's *Saint Paul Restored to Sight* in the Church of the Capuchins.[2]

In an appraisal of the Suida-Manning Collection before it arrived in Austin, the subject of this drawing was misidentified as *The Battle of Maxentius* after Rubens. Despite the poor condition of the sheet, it is clear that it is, in fact, Fragonard's copy of Rubens's oil sketch for *The Reconciliation of the Romans and the Sabines.*[3] Fragonard's trip to Italy in the company of Pierre-Jacques-Onésyme Bergeret de Grancourt (1715–1785) that began in October of 1773 and concluded eleven months later is well documented. In her thorough study of Fragonard's drawings of northern masters, Sophie Raux has argued convincingly for a slightly earlier trip that the two men made to Flanders and Holland in the summer of 1773, specifically citing *The Reconciliation* as the lost pendant made from two works in the collection of the banker Daniel Danoot in Brussels.

1. Pierre Rosenberg, *Fragonard* (New York, 1988), 121–141.

2. Anatole de Montaiglon and Jules Guiffrey, *Correspondence des Directeurs de l'Académie de France à Rome* (Paris, 1901), volume II , p. 199, 239, 243, 317.

3. McGrath 1997, cat. 43c; figs. 140 and 145; 223.

38. Circle of Jean-Honoré Fragonard
A Roman Vault with a Cow Herd
Last quarter of the 18th century

Brown wash, heightened with white on laid paper,
mounted to card

23 × 36.4 (9⅛ × 14⁵⁄₁₆)

Inscription: Illegible marks at bottom right in black ink

The Suida-Manning Collection, 271.1999

As director of the French Academy in Rome, Charles-Joseph
Natoire strongly encouraged his students to draw from nature
in the countryside surrounding the city. Fragonard, along with
Hubert Robert and a number of other *pensionnaires*, heeded this
advice, making long sojourns to sketch landscapes and ruins
in the environs of Rome. Among Fragonard's most admired
drawings—all in red chalk—are those he made of Tivoli and
the Villa d'Este in 1759 while traveling in the company of the
amateur and collector Abbé de Saint-Non.[1] A similar interest
in subterranean vaults and the lighting effects they can create,
such as the one pictured in the Blanton example, is apparent
in the drawings of the interior of the stables of Maecenas at
Tivoli by several artists, Fragonard only one among them.[2]

Fragonard did not begin to use ink washes in the manner
of the Blanton drawing until his second trip to Italy in 1773–
1774 with Pierre-Jacques-Onésyme Bergeret de Grancourt. As
a collector and amateur, Bergeret also produced drawings on
the trip, and his journals hint at some of the men's meetings
and outings with other artists along the way, such as François-
Andre Vincent, who may have accompanied them to Naples.[3]
In this sheet the emphasis is clearly on the architectural and
geometric as well as on the ability of light to carve out and
define complex spaces. The drawing's author is still unclear,
but we know it is not Fragonard.

1. Pierre Rosenberg, *Fragonard* (New York, 1988), 94–117.

2. Ibid., cat. 29, fig. 3.

3. Ibid., 363.

39. After Giovanni Benedetto Castiglione
Noah Leading the Animals into the Ark
c. 1780

Brush with oil paint on antique laid paper, laid down

39.7 × 55.3 (15⅝ × 21¾)

Inscriptions: "Dessin de Benedete Castilione—N° 157 de la vente de Robert—N° 18 de lenventaire [sic]," in brown ink on three fragments of older paper applied to the mount, verso, at lower left

The Suida-Manning Collection, 274.1999

References: Dayton 1962, cat. 77 (as Castiglione, illustrated); New York 1964, cat. 51 (as Castiglione, illustrated); New York 1996, 34 (as "an exact replica").

The Mannings exhibited this sheet as an original work by Castiglione in both of their pioneering exhibitions of Genoese art, and it seems that they continued to regard it as such. Indeed, the subject of Noah leading the animals into the ark is one that the artist essayed so frequently, in repertory fashion and in all media, that it remains emblematic of his oeuvre. The Suida-Manning Collection includes an important early example.[1] Brush and oil on paper was also Castiglione's most distinctive technique and, during his last decade, his preferred approach to drawing. The autonomous function of this sheet, to be gathered from its large size and pictorial finish, is equally characteristic. Given the Mannings' enthusiasm for the Genoese school, their desire to count this drawing among their collection's other nine works on paper by the master is understandable.

In fact, this drawing is a copy of an autograph work by Castiglione. In sheer graphic terms, its nature might have been suspected. Contour is insistent, slow, and frequently clumsy, implying attention to an artistic prototype rather than to nature or idea. The interior modeling of forms is conventional and unfelt, with hatching routine and the impasto, though striking at first glance, routinely descriptive in its application and predictable in its texture. Specific passages like Noah's head, the smaller animals, and the pale horizon line seem superficial and trivial. None of this is consistent with the certainty, relentless rhythm, and peculiar ellipses of Castiglione's hand, or even that of an immediate follower. If these intrinsic qualities were not sufficiently telling, there is the recent identification of the very prototype of this drawing: an autograph work in the collection of Gilbert Butler, now a promised gift to the National Gallery of Art (fig. 1).[2]

There are ample grounds for assigning this copy to an eighteenth-century French artist. Suggestive is the inscription in French on the verso, which was skinned from the back of the original sheet or an earlier support and glued to the modern, laid-paper backing. Discernible in the areas of thin wash on the recto, the original paper's pronounced structure is consistent with those of the period. But the most substantial evidence is contextual and comparative. Eighteenth-century France saw Castiglione's greatest influence and appreciation. Boucher's genre subjects, stroke, and in general his reconciliation of Netherlandish realism and Italian stylization depends on Castiglione's example, while oil studies by Jean-Baptiste Deshays, notably Louvre inv. no. 26199, are explicit *homages* to Castiglione's works in oil-on-paper.

Castiglione's fortune with the brilliant connoisseurs and collectors of the age was even greater. Pierre-Jean Mariette

Fig. 1. Giovanni Benedetto Castiglione, *Noah Leading the Animals into the Ark,* c. 1655, brush and oil on laid paper, 139.4 × 54.8 (15½ × 21⁹⁄₁₆). Partial gift of Gilbert Butler, in honor of the 50th anniversary of the National Gallery of Art. Image courtesy of the Board of Trustees, National Gallery of Art, Washington.

relates that Pierre Crozat acquired "un assez grand nombre de desseins" from a Roman named Pio.[3] Mariette, who adds "l'on n'en peut guères désires de plus beaux,"[4] himself possessed sixteen drawings by Castiglione. Some of these were acquired from his dear friend, the Venetian collector and amateur Antonio Maria Zanetti, who in 1758–1759 published a set of etchings after his own landscape drawings by the artist.[5] Not least, the vast collection of Charles Bourgevin Vialart de Saint-Morys—amassed after 1778 and today in the Louvre—includes some eighteen originals by Castiglione and eight more currently attributed to his workshop.[6]

Still more probative, the enthusiasm of eighteenth-century French artists and collectors coincides in the conspicuous number of contemporary copies after Castiglione's brush-and-wash drawings. The auction of Mariette's collection in 1775 included under lot 357 two copies by Deshays after unidentified subjects by Castiglione.[7] Saint-Morys's collection counts five such copies, two of them large-format brush-and-oil drawings of the *Animals Entering the Ark*.[8] These are by various hands but of the same general character as the present sheet. Most significant, however, is the existence of a second copy of the Butler drawing (fig. 1), executed in monochrome and signed by François-André Vincent (1746–1816). This work was first mentioned by the Mannings[9] when it was in a Parisian private collection. Today in the National Gallery of Art (fig. 2),[10] it proves that the original was in France in the late eighteenth century and the object of considerable appreciation.

1. Bober 2001, cat. 47.

2. Brush and oil paint on brown paper, inv. no.1991.221.1. See Carmen Bambach and Nadine M. Orenstein, *Genoa: Drawings and Prints, 1530–1800* (New York, 1996), cat. 30; Margaret Morgan Grasselli, *Renaissance to Revolution: French Drawings from the National Gallery of Art, 1500–1800* (Washington, DC, 2009), under cat. 98.

3. Pierre-Jean Mariette, *Abecedario de P. J. Mariette et autres notes inédites de cet amateur sur les arts et les artistes: Ouvrage publié d'après les manuscrits autographes conservés au cabinet des estampes de la Bibliothèque impériale, et annoté par MM. Ph. de Chennevières et A. de Montaiglon*, vol. 1 (Paris, 1966), 335.

4. Ibid., 336.

5. Dario Succi, *Da Carlevarijs ai Tiepolo: Incisori veneti e friuani del Settecento* (Venice, 1983), 461–463.

6. See the catalogue in Jacqueline Labbé and Lise Bicart-Sée, *La collection Saint-Morys au Cabinet des dessins du Musée du Louvre*, vol. 2, (Paris, 1987), 201–203.

7. Roseline Bacou, *I grandi disegni italiani della collezione Mariette al Louvre di Parigi* (Milan, 1981), under cat. 62.

8. Musée du Louvre, inv. no. 9482 and 9484; see Labbé and Bicart-Sée, *op cit.*, vol. 2, 203.

9. Dayton 1962, under cat. 77.

10. Inv. no. 2007.80.1; Grasselli, *op. cit.*, cat. 98.

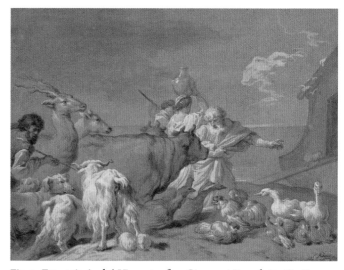

Fig. 2. François-André Vincent, after Giovanni Benedetto Castiglione, *Noah Leading the Animals into the Ark*, 1774, gray-brown wash heightened with white gouache over black chalk on light brown laid paper (originally blue), 41.9 × 55.6 (16½ × 21⅞). Ailsa Mellon Bruce Fund. Image courtesy of the Board of Trustees of the National Gallery of Art, Washington.

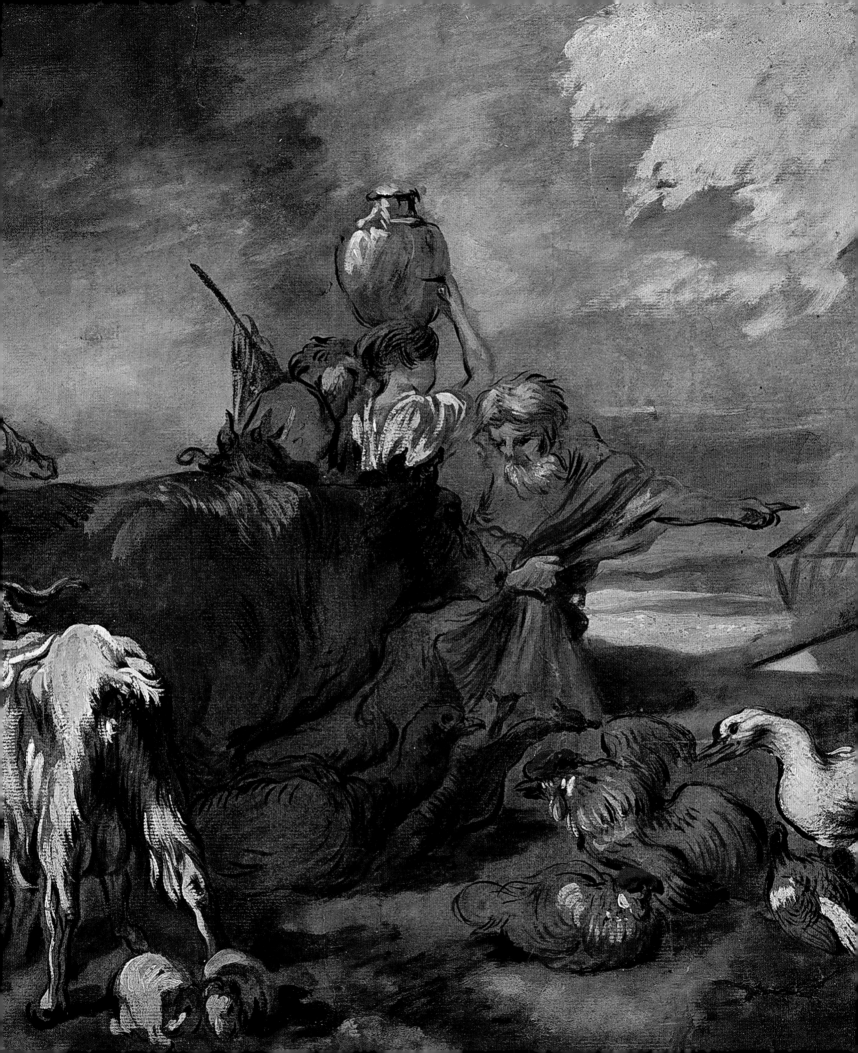

40. Formerly attributed to Jacques Augustin Pajou
Scene from Roman History
c. 1760–1780

Pen and black ink and stumping over black chalk with white chalk
on gray laid paper

35.6 × 49.9 (14 × 19⅝)

Inscriptions: "PAJOU" at bottom center in graphite; "Pajou"
and "Dortu" on verso, crossed out in chalk at center

The Suida-Manning Collection, 427.1999

The attribution to Jacques Augustin Pajou (1766–1828), sug-
gested by the inscription and maintained in records until
now, is rejected by several scholars.[1] Pajou is best known as
a portraitist, although he had aspirations of being a history
painter and certainly submitted works to the Salons in that
vein. His style, however, is neoclassical in nature, with sharp
contours, frieze-like compositions, and high contrasts of light
and shadow.[2] An attribution to his father, the sculptor Augustin
Pajou (1730–1809), is equally untenable, although the drawing
likely belongs to the generation of artists prominent in the
1760s and 1770s. The inscription may refer instead to Pajou's
collection rather than to him as the author of the sheet. If this
is the case, we know that Pajou had mingled with his drawings
those of Lagrenée, Gabriel François Doyen (1726–1806), and
Hubert Robert (1733–1808).[3] Further research into Doyen may
bring us closer to a resolution.

An unusual aspect of this drawing is the degree to which
the artist used stumping, not only to soften the line and to
remove or manipulate the chalk but also to draw with it. Ink
was then used on top of the chalk to reinforce the forms rather
than to delineate the forms first and model them later with the
softer medium.

1. I would like to thank Margaret Grasselli, Perin Stein and Guilhem
Scherf for conferring with me on this work.

2. Philippe Nusbaumer, "Le peintre Jacques Pajou, fils du sculpteur: de
la difficulte de se fair un prenom," in *Augustin Pajou et ses contemporains,
Actes du collque, musee du Louvre, 1997* (Paris, 1999), 559–577. For a catalogue
raisonné of the artist's work, see Nusbaumer, *Jacques-Augustin-Catherine
Pajou (1766–1828): Peintre d'histoire et de portrait* (Le Pecq-sur-Seine, 1997).

3. Marianne Roland Michel, "Sur quelques collections d'artistes au XVIIIe
siècle" in *Collections et marchés de l'art en France au XVIIIe siècle*, edited by
Patrick Michel (Bordeaux, 2002), 143.

41. Formerly attributed to Raymond Lafage
Christ Presented to the People
Late 18th century

Black chalk, pen and brown ink on paper, laid down on card
23.5 × 38.1 (9¼ × 15)
The Suida-Manning Collection, 352.1999

Like *Supplicants before an Emperor* (cat. 20), this drawing was
also attributed to Raymond Lafage. While the hasty manner in
which the present sheet was executed reminds us of Lafage's
virtuosity, it is less organized conceptually and lacks subtlety
and confidence in its articulation of the figures. The repeated
corrections to arms and legs and the constant stopping and
hesitation signaled by the blots of ink marring the composition
are uncharacteristic of Lafage. The composition itself, arranged
like a frieze on a single plane, is more typical of neoclassicism
at the end of the eighteenth century than baroque art of the
seventeenth. What is energetic and dynamic in Lafage's (or
even Boitard's) drawings here becomes frenetic.

The subject is taken from the Gospel of John (19:5), which
describes the Passion of Christ. Pontius Pilate, the Roman
governor of Judea seated in Jerusalem, presents Christ to the
crowd before His execution.

42. François-Marius Granet

Aix-en-Provence 1775–1849 Malvalat

Monks Entering a Cloister

1802–1819

Pen and brown ink with brown and gray washes
on ivory wove paper

17.8 × 24.5 (7 × 9⅝)

Provenance: David and Constance Yates Fine Art, New York;
by purchase from Yates, 1987.

Archer M. Huntington Museum Fund, 1987.18

In 1802, after a provincial education in drawing, a trip to Paris, a few commissions, a stint with the revolutionary army where he recorded battles and military life, and a brief stay in the studio of Jacques-Louis David (1748–1825), Granet made a long-anticipated trip to Rome. He stayed in Italy for nearly twenty years. Infinitely inspired by the monumental ruins, architecture, and countryside, Granet wrote in his memoirs, "Every day I found new subjects to paint, for to know Rome well takes not six months, nor six years—no, it takes a lifetime."[1] Initially, he was attracted to Dutch and Flemish art through the prints of Adriaen van Ostade (1610–1685) and David Teniers and—later when he arrived in Paris—by their paintings in the Louvre. From these works he developed an interest in moody, atmospheric effects and complex architectural compositions. While traveling through Italy, he expressed an admiration for the paintings of Domenichino and Sebastiano del Piombo.

The present sheet is typical of much of Granet's production: monochromatic, severe, and romantic. Sunlight floods the vaulted passageway but is quickly swallowed up by a dense, cool darkness that frames the action. Monks file through in a single row, in silence, heads bowed, hands clasped in prayer. While the subject of monks exercising their religious obligations seems innocuous today, it should be noted that Granet was painting these images during the Napoleonic wars—a time when the religious orders were suppressed for political purposes. Priests and monks were forbidden from wearing their robes and shaving their heads. Granet painted dozens of such canvases and small-scale watercolors and found a ready market among the aristocracy and clergy.

1. Edgar Munhall, *François-Marius Granet: Watercolors from the Musée Granet at Aix-en-Provence* (New York, 1988), 28.

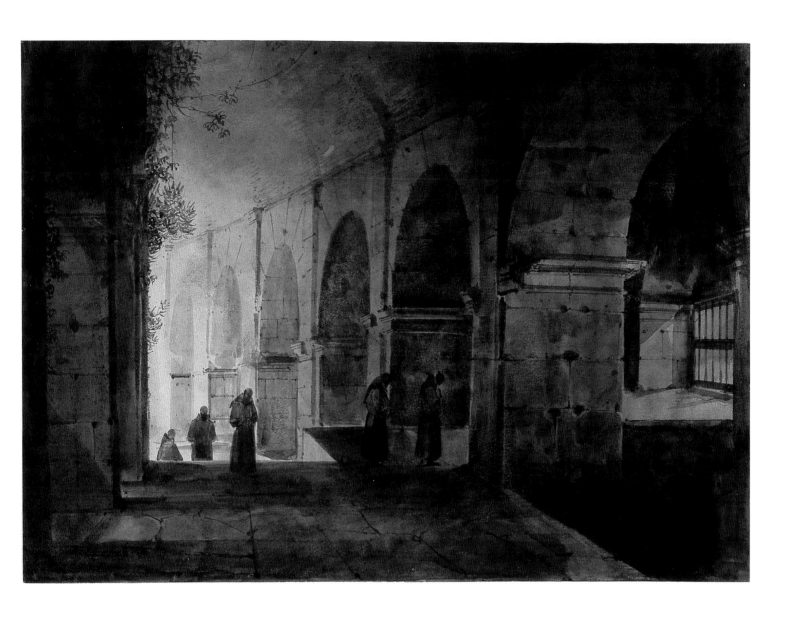

43. Henri-Joseph Hesse
 Paris 1781–1849 Paris
 Portrait of a Man
 1811

 Brush with brown ink and white heightening over traces of black chalk on beige wove paper

 23.5 × 19.4 (9¼ × 7⅝)

 Inscriptions: Signed "Hesse" and dated "1811" on the mount in ink

 Provenance: David and Constance Yates Fine Art, New York; by purchase from Yates, 1987.

 Archer M. Huntington Museum Fund, 1987.19

In this sheet Hesse's draftsmanship is fine and precise, and the composition is compact, recalling the neoclassical exactitude espoused by his teacher, Jacque-Louis David (1748–1825). Hesse focused his efforts exclusively on portraiture, occasionally couching them as genre scenes. He began showing at the Salons in 1808. His talent was eventually recognized, and he enjoyed the patronage of the aristocracy, making portraits of Caroline Murat, Napoleon Bonaparte's sister (1811)[1]; the Count and Countess of Polignac (1816); Baron Dominique Vivant-Denon (1816)[2]; the Duchess of Berry (1819); and Louis-Philippe (1825) before he became king. Although Hesse's small, oval, bust-length likenesses are formulaic and show little of the invention and nuance redolent in the portraits by his contemporary, J.A.D. Ingres (1780–1867),[3] they are not without their charms.

1. Now in the Bibliothèque Thiers, Paris.

2. Etching by Mary Dawson Turner after Hesse in the National Portrait Gallery, London.

3. Another especially handsome example of Hesse's male portraits in gouache is found at Harvard University Art Museums, Fogg Art Museum (loan from the Collection of Jeffrey E. Horvitz). inv. no. D–F-941.

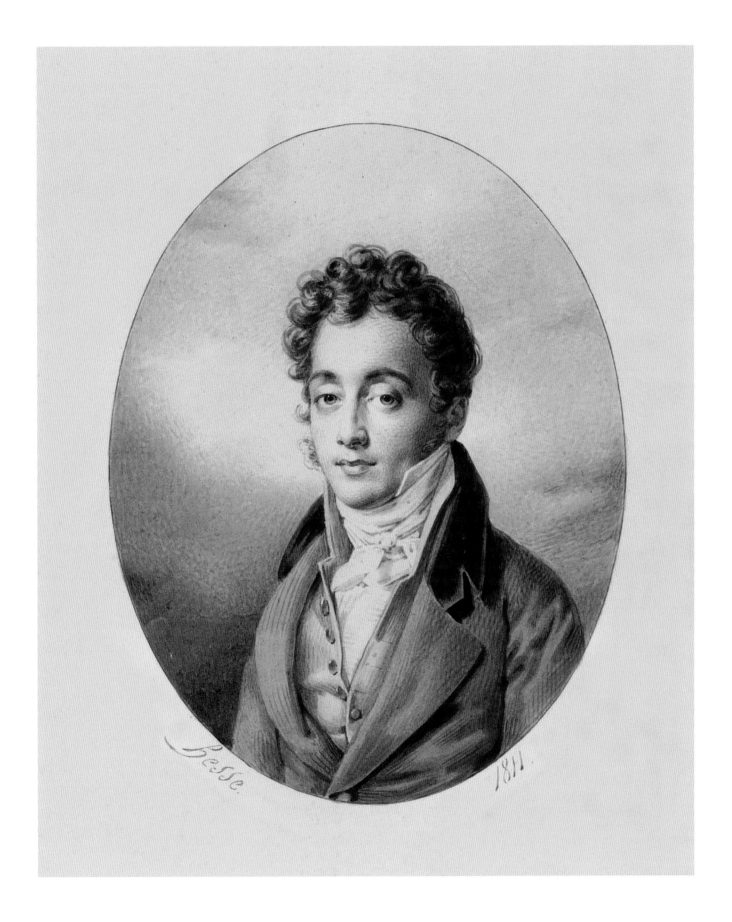

Hesse 1811.

113

44. Formerly attributed to Augustin de Saint-Aubin

A Reception at the Hôtel de Ville

Late 19th century

Black chalk with gray wash and pen and black ink on cream
antique laid paper

19.5 × 26.8 (7¹¹⁄₁₆ × 10⁹⁄₁₆)

Provenance: N. G. Stogdon, New York; The Blanton Museum of
Art purchase, 1987.

Archer M. Huntington Museum Fund, 1987.14

Purchased as a drawing by the eighteenth-century artist
Augustin de Saint-Aubin (1736–1807), this work is now thought
to be a later pastiche in keeping with the rococo revival (see
cat. 45). Indeed, the publication of a biography of the artist by
the brothers Goncourt in 1880 created a market for his work
that encouraged forgeries.

Augustin came from a family of artists and focused on
drawing and printmaking. A survey of prints by him found
no related works. The subject is certainly typical of the
images both Augustin and his more famous brother Gabriel
produced: genre scenes of elegant court life, including
concerts, promenades, and dances. While certain passages are
especially pleasing—the group in the lower right corner, for
example—others seem too stiff to be by Saint-Aubin. There is
simultaneously a hardness of individual strokes and a lack of
precision that suggests an author other than Saint-Aubin.

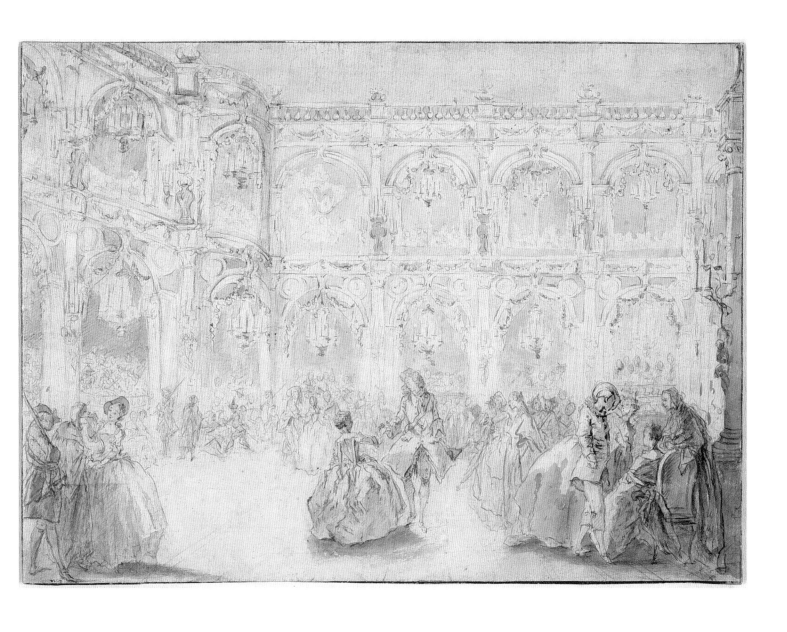

45. In the style of Elisabeth Louise Vigée-Lebrun
Portrait of a Woman
Mid-late 19th century

Pastel on board

67 × 49.2 (26⅜ × 19⅜)

Provenance: By descent to Mr. Clarence Dillon, Corpus Christi, Texas; purchased from Dillon by W. C. Blackburn, Mobile, Alabama.

Gift of Mr. and Mrs. W. C. Blackburn, 1966.5

Once attributed to Jean-Baptiste Nattier (1678–1726), this pastel is now recognized as a nineteenth-century pastiche of a lost portrait by Elisabeth Vigée-Lebrun.[1] Despite being demoted to an anonymous artist of a later date, the work is nevertheless important as an example of the rococo revival much in vogue after mid-century, patronized by the Empress Eugènie, and celebrated by Edmond and Jules de Goncourt in their multivolume study *L'Art du XVIII siècle* (Paris, 1881–1884).

The fashion for things rococo during the Second Empire and Third Republic has been seen as a middle-class attempt to appropriate the taste and decorum of an aristocracy discredited by the revolution but still authoritative in the arena of culture.[2] The return to a style, subject, and medium emblematic of the eighteenth century suggests a rejection of a society that had become increasingly industrialized, modernized, and—to some—vulgar and coarse. Made popular in the eighteenth century by such artists as Quentin de la Tour, Vigée-Lebrun, and Nattier, pastel had fallen out of use until the rococo revival inspired the impressionists—namely Edgar Degas and Pierre-Auguste Renoir—to take it up again and push it to its expressive limits.

1. Joseph Baillio of Wildenstein & Company, e-mail message to author, 8 May 2008.

2. Carol Duncan, *The Pursuit of Pleasure: The Rococo Revival in French Romantic Art* (New York and London, 1976).

46. Théodore Rousseau
 Paris 1812–1867 Barbizon
 A Marshy River Landscape
 c. 1845

Charcoal heightened with white chalk on pink wove paper

23.3 × 43 (9³⁄₁₆ × 16¹⁵⁄₁₆)

Inscription: "T.H. Rousseau" at bottom left in brown ink

Provenance: P. & D. Colnaghi and Co., London; Michael Ingram, Cirencester, England, by purchase from Colnaghi, 1952; Ingram sale, Sotheby's, London, 8 December 2005, lot 111; The Blanton Museum by purchase from auction, 2005.

Gift of Mr. E. Wyllys Andrews IV, Charles and Dorothy Clark, Alvin and Ethel Romansky, and the children of L. M. Tonkin, and University purchase, by exchange, 2006.7

The elevation of landscape in France in the nineteenth century as a genre of painting sufficient in itself and independent of any anecdotal content is due largely to the efforts of Théodore Rousseau. As a student, he had attempted to win the Prix de Rome for landscape painting in order to travel to Italy, but he failed. He subsequently became intensely nationalistic, never leaving France and seeking the poetry and mystery associated with nature in the forests and plains of his native country.

Known as the *"grand refusé"* for continually being rejected from the Salons between 1836 and 1841—and then his refusal to submit works to the jury from 1842 until after the revolution of 1848—Rousseau finally achieved international acclaim for his "romantic-naturalist" landscapes when he was given a gallery at the Exposition universelle in 1855.

Until the middle of the nineteenth century, charcoal was used almost exclusively for preliminary sketches because the medium is easily manipulated and removed, making it ideal for working out ideas on paper. Once fixatives that made the charcoal adhere to the support were invented, artists began to use charcoal for finished drawings, such as this one.[1] The majority of Rousseau's drawings are in chalk or pen and ink. He seems to have used charcoal infrequently and then for finished drawings even more rarely. If this is a preliminary drawing, no finished work has been found.[2]

Rousseau chose a very deep rose-colored paper, now faded to a soft pink, that would have increased the intensity of the poetic drama of dawn or dusk (see Grant's essay on page 142). He sometimes used yellow paper; on at least one occasion he used blue paper for a preparatory drawing (1845) for the painting *La Forêt en hiver*.[3] Given the original intensity of the pink paper, the vermilion fleck he added to the cow would have been quite subtle and does not suggest a preliminary sketch, but something deliberate. Moreover, the artist drew a border in ink around the sheet, now partially cropped, a custom he imitated from his seventeenth-century Dutch models to signal a drawing as finished.[4] Finally, the Blanton sheet is signed in ink, unlike many of his working drawings, which bear only his studio stamp. He sketched the subject of cattle wading in a marshy landscape several times, most notably in 1844,[5] lending credence to a date of circa 1845 proposed by the auction house in 2005.

1. For the fullest discussion of the medium and its properties, see V. and T. Jirat-Wasiutynsky, "The Uses of Charcoal Drawing," *Arts Magazine* 55 (October 1980): 128–135; and J. Jirat-Wasiutynsky, "Tonal Drawing and the Use of Charcoal in Nineteenth-Century France," *Drawing* 11 (March–April 1990): 121–124. Drawings in charcoal were first accepted into the Salons in the 1840s, with treatises on charcoal drawing published in the 1840s. The earliest dated publication is Maxime Lalanne, *Le fusain* (Paris, 1849); followed by Armand Charnay, *Le dessin au fusain* (Paris, 1865) and J. L. Tirpenne, *Le paysage au fusain* (Paris, 1867); A. Allongé, *Fusain* (Paris, 1873); and Karl Robert, *Le fusain sans maitre: Traité practique et complet sur l'étude du paysage au fusain* (Paris, 1874).

2. Schulman identified a charcoal drawing of a thatched cottage that is preparatory to a finished drawing in watercolor and crayon over graphite dating to about 1865, now in the Walters Art Museum, Baltimore. Michel Schulman, *Théodore Rousseau* (Paris, 1997), 303, cat. 641.

3. The drawing is now in the Louvre, Paris; the painting is in the Metropolitan Museum, New York. See volume one of Schulman, 216, cat. 393.

4. Simon Kelly in *The Essence of Line: French Drawings from Ingres to Degas* (Baltimore, 2005), 330.

5. Schulman, 184, cats. 300 and 301.

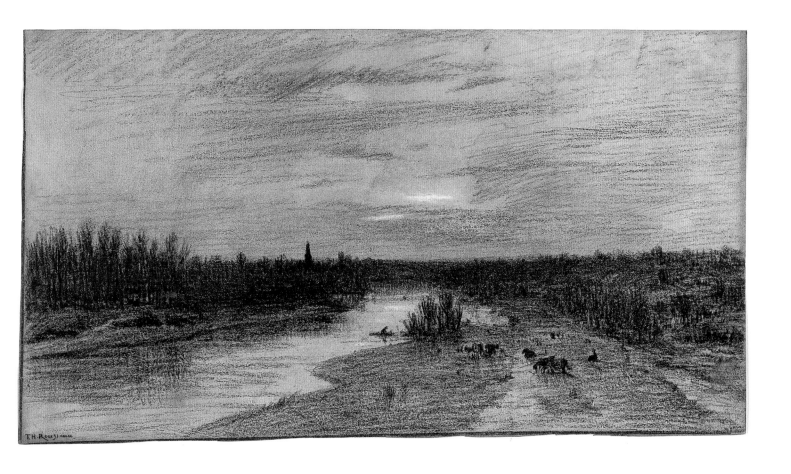

119

47. Adolphe Appian

Lyon 1818–1898 Lyon

Un Soir

c. 1890

Graphite, ink, and scratching on Gillot paper

12.1 × 18.7 (4¾ × 7⅜)

Inscriptions: Signed "Appian" at bottom left in ink; "-un Soir-"
at bottom center in ink; "105" at top right in graphite; "A. Appian"
and a circular monogram stamped in purple (Lugt, n.d.) at bottom
right quadrant of mount; "succession Gruyer. Appian 1959 / Coll."
written in blue ink in lower right quadrant of mount beneath
the stamps

Provenance: Purchased from Joel R. Bergquist Fine Art, Stanford,
California, 2009.

Purchase through the generosity of Dr. and Mrs. Glen D.
McCreless, 2009.28

Appian was best known and most appreciated for his charcoal drawings and his etchings, but he was no less a painter who took his cue from Charles-François Daubigny (1817–1878) and Camille Corot (1796–1875). He participated in every Salon in Paris held between 1852 and his death in 1898, many exhibitions in the provinces, and the world's fairs of London, Chicago, Buenos Aires, and Vienna.

This small drawing was made after the painting *Un soir, étang de Chavollet* (fig. 1) exhibited in Paris at the Salon of 1890 (Musée des Beaux-Arts, Dijon). Critics praised the painting. In an album recording his sales, Appian noted six versions of this composition in both oil and charcoal. Although no reproduction has yet been found, the present drawing was made preparatory to a reproductive print of the much-admired painting. Produced on a machine-made, heavy, prepared, lined board called "Gillot" paper after its inventor, the sheet bears all the detail necessary for transferring to a plate (see Grant's essay on page 146). A member of the *Societé d'aquafortistes* (Society of Etchers), whose goal was to produce and popularize original etchings, Appian also made some reproductive prints after his friends' work, such as Daubigny's *Valée d'Optevoz*, and he is known to have reproduced some of his own paintings and drawings as prints.

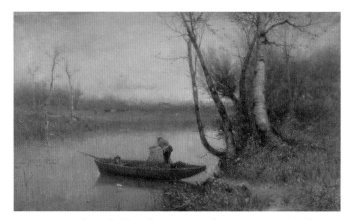

Fig. 1. *Un soir, étang de Chavollet*, c. 1890, oil on canvas, Musée des Beaux-Arts, Dijon.

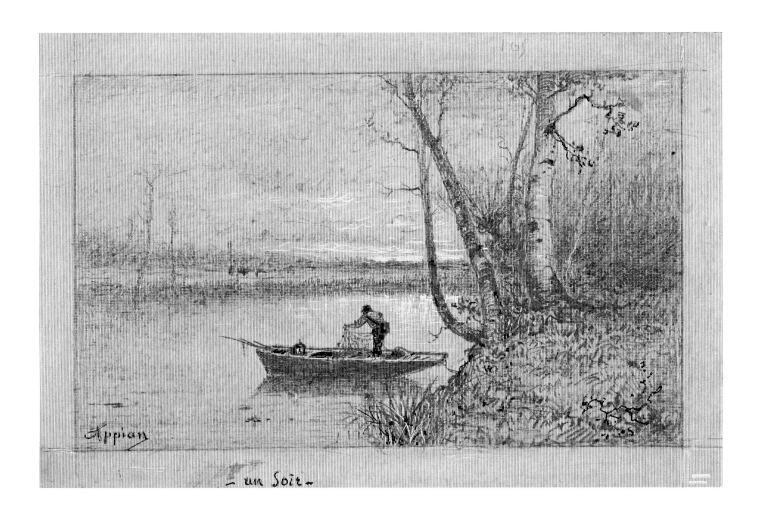

Appian

— un Soir —

48. Edouard de Beaumont
 Lannion 1821–1888 Paris
 Untitled (lady with a cat, recto; lady
 at a piano, verso)
 c. 1880

 Graphite on wove paper

 31.4 × 20.3 (12⅜ × 8)

 Inscription: "H.G" in circle [Lugt 1311] stamped in pink
 at bottom right

 References: McCauley 1985, 18.

 Provenance: Hector Giacomelli (1822–1904).

 Gift of Alvin and Ethel Romansky, 1978, 1982.290

Edouard de Beaumont traveled to Italy but seems to have taken no interest in classical art or antiquity. Instead, he was a practitioner of the rococo revival. Beaumont sent work to the Salons for more than thirty years and was one of the cofounders of the *Société d'Aquarellistes français* (Society of French Watercolorists) in 1879. But he is probably best known as an illustrator and lithographer, ranking with Paul Gavarni (1804–1866) and Achille Devéria (1800–1857) just below Honoré Daumier (1808–1879).

Women were Beaumont's favorite subject.[1] A contemporary biographer wrote of him, "[He] has sung of woman. He has made her, but always a little maliciously, the center of his conceptions, the pivot of his attentions. Like all adorers of form he has placed in the azure the pedestal where towers audacious, superb, divine the being superior by her weakness, before whose throne all earthly powers kneel."[2] In The Blanton sheet, a middle-class, tightly coiffed young lady in fashionable attire addresses a cat lounging in a vaguely described interior. Her slight frame, mincing gestures, and delicate features echo the precious self-indulgence associated with the art of the ancien régime. Heavily reworked, scraped and redrawn, this casual, immediate scene was composed with great consideration.

The drawing is notable, too, for its provenance. Hector Giacomelli (1822–1904), an artist specializing in birds and a talented book illustrator, is perhaps best known as a collector and connoisseur. He was recognized as one of the champions of modern art and assembled an impressive collection of prints, organizing an exhibition for the Exposition universelle in Paris in 1889. That Beaumont's work was included in Giacomelli's holdings is an indicator of the artist's achievement.

1. For a thorough discussion of this artist, see L. Struminger Schor, *Les Jolies femmes d'Edouard de Beaumont* (New York, 1994).

2. E. Montrosier, "Edouard de Beaumont," in *Society of French Aquarellists*, ed. Edward Strahan (Paris, 1883), 162.

49. Alexandre-Louis Leloir
 Paris 1843–1884 Paris
 Moroccan Girl Playing a Stringed Instrument
 1875

 Watercolor, gouache, and graphite on ivory wove paper
 24.5 × 34.5 (9⅝ × 13⁹⁄₁₆)
 Inscription: "Louis Leloir 1875" at top left in black ink
 Gift of the Wunsch Foundation, Inc., 1983.133

Leloir won the Prix de Rome in 1861 and medals in subsequent Salons in the 1860s for his history paintings (*The Death of Priam*, 1861; *Massacre of the Innocents*, 1863; *Daniel in the Lion's Den*, 1864, *Jacob Wrestling an Angel*, 1865, Musée d'Art Roger-Quilliot, Clermont-Ferrard). He was a member of the *Société d'Aquarellistes français*. He was especially admired for his draftsmanship and—like any good, academically trained artist—the research and preparation that made his paintings and watercolors historically or culturally accurate.[1] To that end, he collected musical instruments, such as the one depicted here, as well as costumes and artifacts that he incorporated into his work. As is evident in the Blanton drawing, his color harmonies were especially rich and the drawing precise.

Such meticulously rendered, diminutive sheets were regarded as affordable and manageable signifiers of larger and older paintings: "The watercolorist is a decorative painter who often makes a Veronese on a bit of paper."[2] Linked more closely with the rococo revival, Leloir's watercolors were compared with Tiepolo's ceiling paintings and even more aptly with Watteau and Fragonard.[3]

1. Jules Claretie in *Société d'Aquarellistes français* (Paris, 1883), 273.

2. "L'aquarelliste est un peintre décorateur qui souvent fait du Veronèse sur un bout de papier." Claretie, 277.

3. "Il n'imite ni Watteau ni Fragonard: il les continue." Claretie, 288.

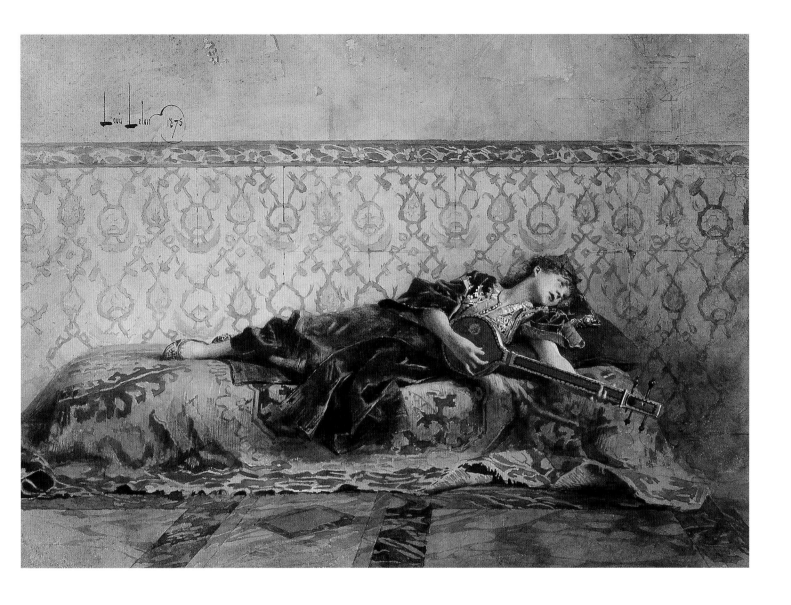

50. A. Belloguet

 Active 1850–1873

 Study for *A quelle sauce. . . ?*
 c. 1872
 Pen and brown ink over graphite on wove paper
 27.9 × 22.4 (11 × 8¹³⁄₁₆)

 A quelle sauce. . . ? from *Fantaisies satiriques*
 c. 1872
 Pen lithograph
 33.2 × 27 (13¹⁄₁₆ × 10⁵⁄₈)

 Gifts of Alvin and Ethel Romansky, 1978, 1982.294–295

In the tumultuous years following the Franco-Prussian War and Commune (1870–1871), political caricature flourished. Adolphe Thiers, the president of the newly established Third Republic, is shown taking snuff, trodding on the old empire, and wearing the Phrygian cap, a familiar revolutionary symbol. However, beneath his costume can be seen an aristocratic ponytail and knee breeches, which indicate his secret sympathies for the ancien régime. On the right is a candle, labeled as the "Republic," being snuffed out by "reaction"; and on the rear wall looms the shadow of the Gallic cock. The accompanying quatrain advises Thiers to quit playing games and warns him not to be duped by royalist members of the legislature who were seeking a return to monarchy after the fall of Napoleon III in 1870.

 Little is known about this artist other than that he worked for such publications as *La Chronique illustrée*, *L'Eclipse*, *L'Esprit follet*, *Le Journal amusant*, and *Petit journal pour rire*.[1] A watercolor version of this cartoon exists at the Musée d'art et d'histoire, Saint Denis, and includes the dagger on the floor between Thiers's feet, a detail missing from the Blanton's preliminary sketch and present in the lithograph.

1. Marcus Osterwalder et al., *Dictionnaire des illustrateurs, 1800–1914: illustrateurs, caricaturists et affichistes* (Paris, 1983), 115.

51. Jean-Louis Forain

Reims 1852–1931 Paris

The Family

c. 1890s

Charcoal with stumping on buff paper

26.7 × 44.3 (10½ × 17⁷⁄₁₆)

Inscription: "forain" at bottom left in charcoal

Provenance: Christian Humann (d. 1981); Sotheby's sale, New York, 21 January 1983, lot 279; purchased by Spencer A. Samuels & Co. Ltd., New York; purchased by Hooks-Epstein Gallery, Houston, 1984; purchased by Latané Temple.

Gift of Latané Temple, 1985.97

Forain learned to draw from the sculptor Jean-Baptiste Carpeaux (1827–1875) and the caricaturist André Gill (1840–1885). He counted among his friends Édouard Manet (1832–1883) and Edgar Degas (1834–1917) and exhibited at the impressionist exhibitions in 1879, 1880, 1881, and 1886. Although he shared with Degas an interest in depicting ballet dancers, cafés, and theaters, his work tends to be darker and more cynical. The sunken-eyed, ghostly faces emerging from the shadows in this sheet are similar to portraits by the symbolist artist Eugène Carrière (1849–1906).[1]

In 1985, the drawing was given to the museum by Latané Temple, an alumus of the University of Texas, who became an artist and later a gallery owner after leaving the family businesses (Temple Industries) and moving to San Miguel de Allende that year.[2] When he attended the university in the 1930s, there were no studio art classes offered, and he explained that he learned "to model a figure, particularly to see varying intensity of shading."[3] With this in mind, it is easy to understand the significance of Forain's drawing to the artist-cum-collector.

1. See, for example, Carrière's *Portrait of the Artist's Family*, 1893, Musée d'Orsay.

2. Latané Temple did not consider himself a collector, but he had acquired several hundred works by European, American, and Latin American artists, including Camille Pissarro, George Inness, Georges Braque, Alexander Calder, and Wifredo Lam. Some of these were donated to the Archer M. Huntington Art Gallery—now The Blanton Museum of Art—in 1985 with the majority of them going to the Museum of East Texas in Lufkin, where Temple lived in 1996.

3. Interview by J. P. McDonald in *The Lufkin Daily News*, October 8, 1996, 3B.

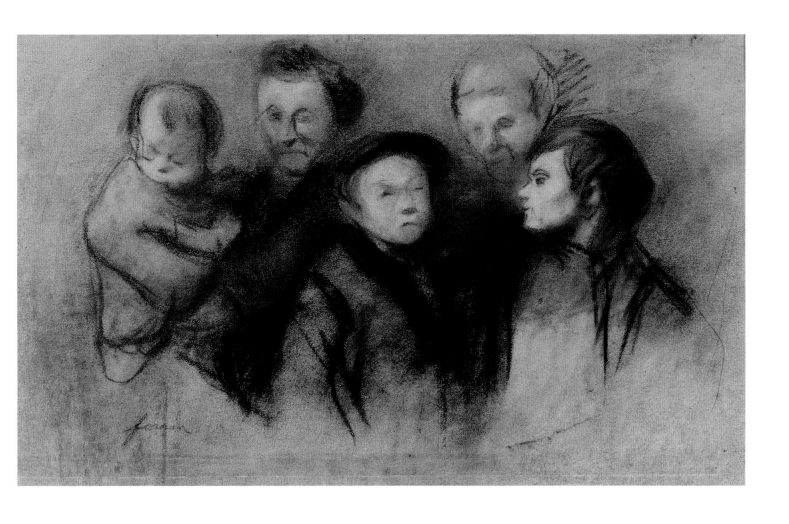

52. Frédéric Jacque
 Paris 1859–unknown
 Workers Loading Ballast
 1881

 Black chalk with touches of white on gray laid paper

 41 × 59.9 (16⅛ × 23⁹⁄₁₆)

 Watermark: MICHALLET

 Inscriptions: "F. Jacque 81" at bottom right in chalk; "bleute clair / 8 de marge 75 60" on verso, at bottom right in graphite

 Provenance: David and Constance Yates Fine Art, New York.

 Archer M. Huntington Museum Fund, 1987.20

Son of the Barbizon artist Charles Jacque (1813–1894), Frédéric was not well known, even in his own era. Nevertheless, this sheet is a grand attempt at carrying on the legacy of Jean-François Millet (1814–1875), whose efforts to monumentalize the peasant were well established by the end of the century.

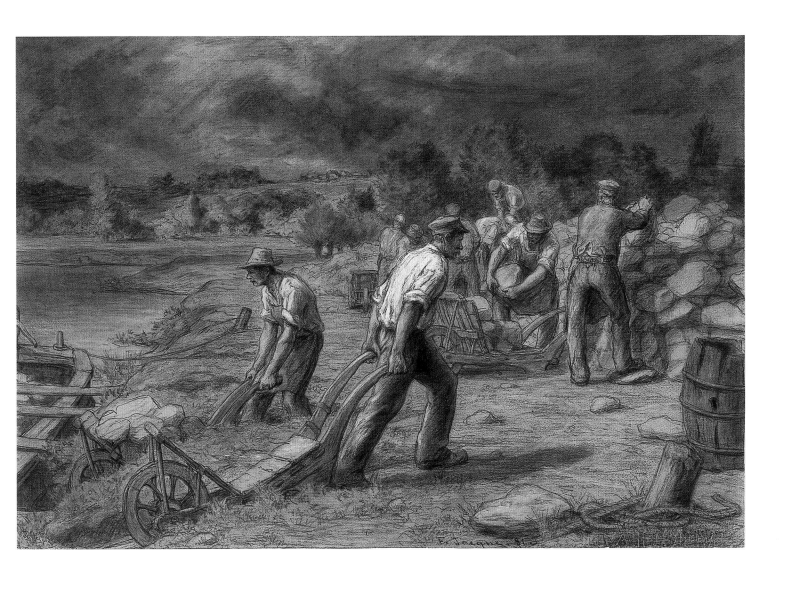

53. Théophile Alexandre Steinlen

Lausanne 1859–1923 Paris

À l'atelier

c. 1895

Graphite on wove paper

29.2 × 16.8 (11½ × 6⅝)

Inscriptions: "Aurelien Scholl" at top left in graphite; "A L'atelier /" at top right; "PAROLES / DE / ACHILLE BLOCH / MUSIQUE / DE / LOUIS BYREC" at bottom right; "St" at bottom left

Gift of Alvin and Ethel Romansky, 1978, 1982.616

Le Chat Noir, the cabaret opened by Rodolphe Salis (1851–1897) in Montmartre was a hotbed of the socialist/anarchist movement and an incubator for the avant-garde artists whose impact on modern art we now celebrate. Steinlen, along with Henri Toulouse-Lautrec and Henri Rivière (cat. 54), began his career as an illustrator there in 1883. Over the decades, he expressed his socialist sympathies in the thousands of illustrations he produced for books, theater programs, and journals, many of them radical.

The present drawing is a study for the cover of a published operetta (fig. 1), likely performed at *Le Chat Noir* or one of the other cabarets in the district. It shows a working-class father, distinguished by his clothes and cap, holding the hand of his young daughter on her way to school. In his right hand he carries her lunch tied up in a handkerchief. He looks over his shoulder at a group of people identified as "a streetwalker and two pimps."[1] Two versions of the final print were made, one in color. The verso of the sheet is covered with red chalk, and the contours of the figures are incised, indicating that he transferred the image to another sheet where he presumably finished the inscription by adding *"Chanson créée par Mévisto à la Scala"* (Song created by Mévisto at la Scala) and the address of the publisher in the lower left.

1. E. de Crauzat, *L'Oeuvre gravé et lithographié de Steinlen* (Paris, 1913), no. 422, p. 118.

Fig. 1. *À L'atelier*, 1895, lithograph, 27 × 17.5. Jane Voorhees Zimmerli Art Museum, Rutgers, The State University of New Jersey. Gift of Norma B. Bartman.

54. Henri Rivière

Paris 1864–1951 Paris

Crépuscule à Landmélus

1902

Watercolor and black chalk on wove paper

34 × 23.3 (13⅜ × 9³⁄₁₆)

Inscriptions: "HR" at bottom left corner stamped in red in reverse and "loguivy Sept. 1902" in chalk; "Crepuscule a Landmélus" on verso, at center in graphite

Gift of Alvin Romansky, 1991.68

Henri Rivière had no formal training in art and began his career as an illustrator. His friend, Paul Signac (1863–1935), with whom he shared a studio in Montmartre, introduced him to Rodolphe Salis (1851–1897), the owner of *Le Chat Noir*. He worked at the famous cabaret with Henri Somm (1844–1907) and Théophile Steinlen (1859–1923) as an artistic director for the publication of the same name. Among the various amusements Salis offered his clients were shadow plays. Rivière showed endless invention in devising the sets for these performances, which were created by placing zinc cutouts between a lamp and a screen and inserting various layers of enameled glass to produce different tonalities and colors.[1] Rivière was equally inspired by the Japanese prints that had become popular at this time and owned a complete set of Hokusai's *Thirty-Six Views of Mount Fuji*, which he regularly plumbed for motifs and compositional devices for his own prints and drawings.

Crépuscule à Landmélus is a confluence of these two themes in Rivière's oeuvre. It belongs to a long series of watercolors the artist produced between 1891 and 1911 while on summer vacation at his home, called Landiris, in Loguivy on the banks of the river Trieux in Brittany. Another watercolor, dated September 1902 and of the same dimensions as the Blanton sheet, shows a nearby cluster of trees but from a closer and higher vantage point and with the sun overhead. Rivière noted the location and date on almost all of these watercolors in order to track the evolution of his technique.[2] This watercolor, more than some of his earlier examples, closely resembles his poetic wood block and lithographic prints with their broad expanses of flat, subtly layered color.

When Rivière finally made a trip to Italy in 1913, he was immediately attracted to the simple and powerful compositions of Cimabue's and Giotto's proto-renaissance frescoes in Florence. He challenged the notion, not too unexpectedly at this date, of Raphael's supremacy: "Raphael is a great painter, certainly, the characters in the *Disputa* and the *Mass at Bolsene*, [and] his portraits are there to prove it. But the manner of a Piero della Francesco, the inventions of a Signorelli, the grace of a Botticelli—are these inferior to the qualities of Raphael? The renown that he [Raphael] had during his lifetime has accrued with time—very well—this is not a sufficient reason to put him above the others."[3]

1. For a thorough discussion of Rivière's shadow play scenes, see Rivière, *Les Détours du Chemin: Souvenirs, Notes et Croquis, 1864–1951* (Saint-Remy de Provence, 2004), 45–59.

2. Valérie Sueur-Hermel, *Henri Rivière: Entre Impressionisme et Japonisme* (Paris, 2009), 106.

3. Rivière, 134.

Loguivy Sépt. 1902

Adolphe Appian, *Un Soir* (detail), c. 1890. Graphite, ink scratching on Gillot paper. The Blanton Museum of Art: Purchase through the generosity of Dr. and Mrs. Glen D. McCreless, 2009.28.

The Forensic Examination of Drawings
Three Case Studies in Technical Observation of Works on Paper

KENNETH M. GRANT

AN EXAMINATION OF artworks from a materials standpoint, such as those presented here, makes clear the value of conservation studies as a tool for the interpretation of artworks. The close, physical examination—a *forensic* examination—of three works from the exhibition from the perspective of a paper conservator leads to a fuller understanding of the objects and the processes by which they were made. And this insight into *how* a drawing was created sheds light on *why* it was created.

In the first case study, Raymond Lafage's *The Elevation of the Cross* (cat. 19) presents several anomalies. A detailed analysis shows the work to be an assembled object, perhaps a workshop construction. This discovery has implications about the artist's creative process and working conditions and about the known interest of collectors in the seventeenth century. Théodore Rousseau's *A Marshy River Landscape* (cat. 46) raises questions about the history, availability, and production of colored paper as a support and the exploitation of its expressive potential in the nineteenth century. Finally, the third case study, Adolphe Appian's *Un soir* (cat. 47) provides a good example of "extinct" paper and explains why this extinction occurred.

Lafage: *The Elevation of the Cross*

Raymond Lafage's *Elevation of the Cross* appears to be a *premier pensée*—an artist's first thoughts about a composition. Very few of his paintings are known, and no finished related work has been found. The base of the cross is set to the left of center so that in the act of raising it, the head of Christ forms the apex of a pyramidal composition. The lower third of the sheet is occupied by a group of men, their muscular bodies straining at the task at hand. A soldier on horseback faces the viewer and appears from behind the crowd. Lafage started by blocking in the masses in black chalk over which he added contours and modeling in pen and iron gall ink. His practice of drawing extended portions of contour in a single long line—without lifting the pen from the surface of the paper—creates a nervous, energetic composition. There are several small, stray doodles in black chalk of men's heads in profile and what appears to be a

bust-length sculpture in the top right quadrant as well as a quick study of a male torso in the top left quadrant. A large ink stain at the center of the work does not correspond to any visible design on the recto. This stain and the stray brush marks at the top of the sheet have a faint coating of white—probably the remains of paint used to hide the anomalous ink marks or at least tone them down (fig. 1).

Anomalies in the design warrant further examination. The bottom corners have been lost and replaced with paper fills of similar weight and surface qualities as the main sheet. However, they cannot be considered attempts at "invisible" mends; the fills are rough and do not disguise the losses. The fill at the bottom right corner was made by using a preexisting drawing that the "restorer" chose to approximate the portion of the original drawing that was lost (fig. 2). In this fragment, the legs of a male figure are articulated in much the same style and materials as those of the central image. The fill also has what appear to be the remnants of a gray paper attachment along the right edge. The image on the fill is inverted and attached to the main sheet in such a way as to make it a complete rectangle, but the lines of the fill do not align with the main drawing. Despite the crudeness of the application, this fill nevertheless successfully masks the loss in a way that a blank-paper fill would emphatically not do. The line density (the number and distribution of ink lines) generally seems correct, and the lines are of matching tone. More significantly, the lines themselves have the appropriate swelling and tapering quality that corresponds to the work on the main sheet.

The fill drawing's orientation helps to disguise the fact that this piece is an image of another figure's legs. In this area of the main drawing, we would expect to see a descending line that continues the curve of the back of the kneeling figure on the main sheet. The restorer explicitly chose to orient the fragment so that the drawing on it would make the overall composition visually "complete." The entire sheet was trimmed to its present dimensions after the fills were inserted and the drawing was lined on the back.

The fill at the bottom left corner is equally curious. It bears the signature "Lafage fecit" and is consistent with the artist's hand when compared with known autograph drawings. At first glance, the signature appears to be entirely on the fill paper. Close examination under the microscope, however, reveals that the crossing of the "t" in "fecit" overlaps the torn edge of the main sheet (see figs. 3 and 4), suggesting the fill was signed after it was placed. The title inscribed at the bottom center is in a different hand.

The entire sheet, with fills added, was then lined with a more finely made medium-weight antique laid paper (suggested by the reduced amount of straw impurities contained in the lining paper). The verso of the sheet is concealed by the lining paper, making necessary an examination using transmitted light. This revealed a drawing that had never before been documented. The drawing is of the same subject (the Elevation of the Cross) but is composed differently (see fig. 5). In this hidden composition, the rider and his horse are more fully developed—with elaborate hatching and shading—than the image on the recto. The figure of Christ on the verso is pushed farther into the background, and the rider is viewed from

Fig. 1. Attributed to Raymond Lafage, *The Elevation of the Cross* (detail of anomalous ink stain at center of sheet). Note the hazy white quality of the stain; it has been covered with a white material, probably a thin paint, in an attempt to make it less noticeable.

Fig. 2. *The Elevation of the Cross* (detail of fill at bottom right corner).

Fig. 3. *The Elevation of the Cross* (detail of fill at bottom left corner).

Fig. 4. *The Elevation of the Cross* (detail of signature at bottom left corner). Note that the crossing line for the "t" in "fecit" touches on the paper of the main sheet at the center of this image. The period of the inscription is shown below the crossing line.

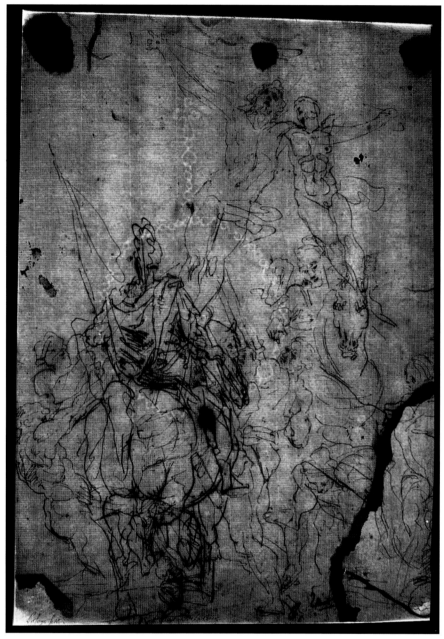

Fig. 5. *The Elevation of the Cross* (transmitted light showing the location of paper fills in the lower corners and adhesive residues on the verso along the top edge).

the back. The emphasis is on the rider and not the Christ figure, resulting in a composition that seems unbalanced. There are no other figures (laborers, bystanders) represented on the verso of the drawing. The cause of the anomalous, intrusive ink stain on the recto was then explained: it is part of the hidden drawing that bled through from the verso.

The drawing was then examined using an infrared camera.[1] Transmitted infrared examination revealed yet another previously unknown figure of the crucified Christ that we assume is on the verso of the main sheet (compare fig. 6 with transmitted visible light detail

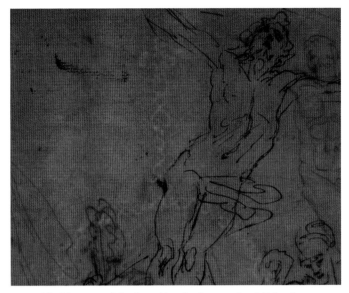

Fig. 6. *The Elevation of the Cross* (transmitted infrared image detail of top half of drawing showing a third image of the Christ figure on cross). Compare with the next image (transmitted light photograph, fig. 7). Note that the Christ figure from the front of the drawing is not visible in this photograph because it is transparent to infrared light (IR) rays—probably because it is drawn in iron gall ink. The rider (whose head is visible at lower left here) and its associated Christ figure (at upper right here) are opaque under IR rays and so are drawn in an ink of a different composition—possibly India ink, which contains carbon black.

Fig. 7. *The Elevation of the Cross* (detail of transmitted light photograph). Note the Christ figure on the recto (slanting toward the upper right) and the Christ figure on the verso (hidden by the lining paper and slanting back toward the left). The head of the rider figure on the verso is near the bottom left. The watermark visible at the center of the image is on the lining paper, not the main sheet.

of fig. 7). This one is larger than the other two and near the center of sheet. It is faintly drawn, probably in black chalk, which is opaque to infrared light rays. The chalk figure on the verso is somewhat like the brief sketch on the recto but more fully developed and very sinuous in form.

Such anomalies could support an attribution to Lafage. It is obvious that the trouble taken with these fills in no way approaches the heroic efforts found in some works to make "invisible," deceptive repairs.[2] The composition on the verso may have been a first attempt. The work in ink may have been considered out of balance—a poor start. The absence of figures at the foot of the cross suggests that possibly the artist decided to start again on the other side of the sheet (the present recto). He moved the rider to the background of the composition and the figure of Christ to the foreground, creating a more balanced, traditional interpretation.

The damage to the corners of the sheet may have occurred in the studio and, in an attempt to salvage work that a collector might find desirable, perhaps the artist selected fragments of paper at hand in the studio to cobble together a repair that was not intended to deceive, but rather to visually integrate the drawing as a whole. The lining may have been added to ensure the strength of the fills and the main sheet generally, and possibly in order to hide the first, less successful attempt at the subject.

The repairs, then, were quite likely done by the artist or in his studio. For this reason, removal of the rather clumsy fills and lining that obscures the second drawing on the verso would not be advisable, as they are possible evidence of the artist's hand and therefore representative of his studio practice.

Rousseau: *A Marshy River Landscape*

Our second case study focuses on Théodore Rousseau's *A Marshy River Landscape*, a large drawing in charcoal on rose-colored paper that has faded through the center of the image from overexposure to light in the window mat of a frame. Some areas along the margin—especially at right—were partially protected from light exposure and retain a vestige of the original, deeper rose paper tone.

What was the visual effect that the artist was trying to capture? In the catalogue for an exhibition held at the Cercle des Arts in June 1867, notes by the critic Philippe Burty describe the subjects of Rousseau's pictures. In one note we get the sense of what the artist was striving for with his use of color: "the 'effect' is of 'bare ground with trees strongly outlined against a wintry twilight of faded rose.'"[3] The artist's choice of a colored paper support—as opposed to coloring a white paper himself using washes of watercolor—is indicative of market responses to shifting concerns and tastes.

The methods of traditional European paper manufacture may give a better context for understanding Rousseau's choice of colored paper. The most important constituent materials in traditional handmade paper were the fibers, either linen or hemp, and later, beginning in the early nineteenth century, cotton. Rags, which were the primary source for the fibers used in papermaking, became the center of an extensive trade. In supplying papermakers with their raw material, rag merchants collected and sorted the fabrics according to many characteristics. Certain schemes simplified the sorting categories from three to five to as many as seventeen discrete kinds of rag. A mid-nineteenth-century French source described the process.[4] Merchants provided rags in bales that weighed between 400 and 1,000 pounds. These bales held either "unpicked" rags or those that had undergone a preliminary sorting into five categories: 1) fine whites; 2) common whites; 3) white cottons; 4) colored cottons; and 5) gray rags and packcloths.

Bales of roughly sorted rags would then undergo an inspection, and foreign matter—such as buttons, hooks, eyes, pins, and the like—as well as seams and hems, which also would not break down properly during further processing, were removed. The rags would then be cut down to short strips of about three to five inches along a side. These pieces were then re-sorted, according to various criteria, into as many distinct categories as was deemed useful given the variety and condition of rags in the bale and the types of paper that were intended to be made from them. This could range from forty to as many as seventy or more possible categories.[5] The papermaker had a keen understanding of the nature of the rags based on their source. In his description of the process, A. Proteaux made this distinction:

The quality of rags varies very much according to the source from which they are obtained. Those collected from great centres of population are fine and white, but not strong. The use of concentrated lyes in bleaching the clothes [*sic*] has considerably injured the resisting power of the fibers. They are, so to speak, burnt, tear easily between the fingers and suffer a considerable waste during their transformation into paper. Country rags, on the other hand, are coarse, of a grayer appearance, but strong, and containing many mending pieces nearly new. As we shall see later, these kinds are very valuable to give body to the paper.[6]

Fig. 8. François Le Moyne, *Dido and Aeneas* (detail of paper fibers showing relatively high percentage by volume of blue fibers in a white-fiber matrix with few impurities).

The papermaker increased his profit margin by taking special care at the beginning of the fiber preparation process, thereby reducing his overhead and raising the quality of the finished product so that the price could be adjusted accordingly.

Several characteristics of the fiber govern the tone and nature of the finished paper, not the least of which are the color of the constituent fibers themselves, their individual tones, and their overall effect in the aggregate in the finished paper. In the early history of papermaking, the color of the sheet was determined by the color of the rags from which the fibers were derived to make the paper "furnish"—a term to describe the type of fibers and the processing used to produce a particular batch of paper. A furnish would include not only the various colors of rags (blue, brown, white), but also shades within those designations, the degree of fineness of the rag fiber, and the extent to which the fibers had deteriorated and softened with use. Each rag type would be washed and macerated in preparation for stamping in a wind- or water-driven mill.

Fig. 9. François Verdier, *Hercules on Olympus* (detail of paper fibers showing yellow tone of (straw) filler). Even a relatively small amount of yellow tone in the furnish, either from filler straw or yellowed white fibers, can have a significant tonal effect in the finished paper.

Colored paper as a drawing support in France is well represented in The Blanton's holdings (see the use of blue paper by François Verdier, François Le Moyne, Charles-Joseph Natoire, and François Boucher). In general, the preponderance of blue paper as a colored paper support is due to the process by which colored papers traditionally were made. Traditional blue dyes, derived from European woad or indigo imported from Asia or Africa, withstood the rigorous treatment and retained their hues better than other colors, such as red and yellow.[8] All colored papers were made of a mixture of colored fibers and white fibers. Papermakers mixed various proportions of the blue and white fibers to achieve a range of finished shades.[9] A detail photograph (fig. 8) of the surface of the drawing by François Le Moyne's *Dido and Aeneas* (cat. 23) shows a high percentage by volume of deep blue and light blue fibers mingled with white fibers. This kind of careful selection of fibers results in a rich blue color.

A comparison with a detail image (fig. 9) of the paper surface from François Verdier's *Hercules on Olympus* (cat. 18) shows a fair amount of blue fibers with white fibers, and, notably, an appreciable amount of yellowish fiber content, a cheap filler material—probably straw—added to bulk out the paper furnish. This adulteration of the fiber content of the paper produces a dull blue, almost green, tone to the sheet.

Fig. 10. Théodore Rousseau, *A Marshy River Landscape* (top edge of verso). This detail of the paper fibers shows a mix of two types (at least) of red fibers in addition to blue fibers and white fibers. Actual width of image area is approximately 2 cm.

An examination of Rousseau's drawing, *A Marshy River Landscape*, indicates that the artist used a commercially made red paper and not a white paper prepared with a red wash, as was sometimes done. Proteaux remarked on the production of "rose paper": "All the red rags whether linen or cotton, dyed with Turkey red [madder alizarine], are set apart; they are treated like the blue, and a red pulp is obtained which gives a very pretty rose color to the paper."[10]

Examples of red paper before the nineteenth century are scarce, and those that survive are extremely faded.[11] Why does red paper appear more frequently in the nineteenth century than in earlier centuries, to the point that it is recognized in the literature? It may be due in part to technological advancements in both the dyes and the machinery used to macerate fibers into paper pulp. Aniline dyes developed in the nineteenth century were sturdier than most of the earlier traditional dyes; they could withstand submersion in water for longer periods of time without losing all of their color. These heartier dyes along with the eighteenth-century development of the Hollander beater, which was faster and more efficient at breaking down fibers than the stamping mill, made the production of rose-colored paper economically viable and profitable. These technological innovations alone, however, are usually not sufficient to generate a new phenomenon. In this case, the ability to produce a particular product— red paper—coincided with a growing market trend among artists for creating "effects": the translation of atmospheric effects using the distribution of light and shade over a surface. Landscape artists of the early nineteenth century focused on sunrises and sunsets, hazy or humid conditions, the reflection of light off of falling snow, and the glow of a street lamp through the rain.

The effect Rousseau attempted here, a sunset, was bolstered by the inherent nature of the support he chose.[12] Having been exposed to light over a long period of time, the Blanton's example has only a vestige of its original paper tone. One area along the right edge of the sheet covered by the mat was protected from light exposure. The verso is lined with thin paper, overall making it difficult to assess the condition of the support's back; however, there is a small damaged portion of the drawing along the top edge that affords, on the verso, a view through the thickness of the sheet (fig. 10). We can see here that the sheet is composed of a mixture of colored fibers. There are two types of red fiber, a darker and a lighter tone, in addition to a small percentage of blue fibers; the balance is white fibers. The presence of blue fibers within the paper indicates that the tone was adjusted in the pulp mixture before the paper sheets were formed.

In an attempt to re-create the original color balance of the paper, we digitally sampled the undamaged portion of the paper at the right edge of the recto, identified its color coordinates, and then digitally replaced the faded tone with the reconstituted one in a digital image of the entire drawing (figs. 11 and 12).[13] The change is subtle, but significant. The modified image shows a richer, more saturated, and atmospheric rose tint suffusing the scene. This exercise serves as a reminder that the appearance of an object changes over time and that what we see today is often not what the artist intended or what his audience saw or understood. It also

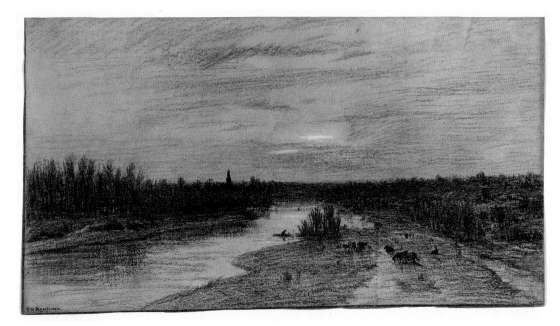

Fig. 13. *A Marshy River Landscape* (detail showing vermilion highlight on figure of horse [?] in middle ground). Actual width of image area is approximately 1 cm.

Fig. 11. *A Marshy River Landscape* (in its present condition).

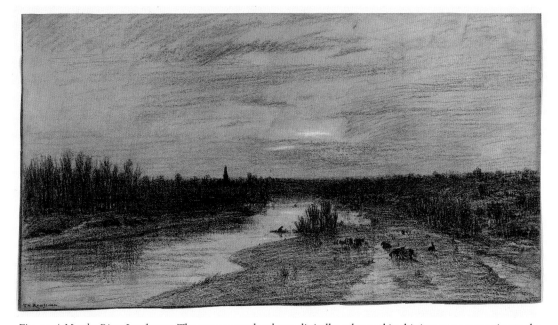

Fig. 12. *A Marshy River Landscape*. The paper tone has been digitally enhanced in this image to approximate the rose tone that it had originally.

makes more surprising a detail that was noticed during examination. Small touches of red paint, only two to three millimeters across, applied by the artist on the livestock grazing in the middle ground (fig. 13), would have been even less distinct when the paper tone was a more saturated, deep rose shade and suggests Rousseau painstakingly built this effect with layers of subtle nuance.[14]

Fig. 14. Adolphe Appian, *Un Soir* (raking light illumination, close-up image of the surface of the Gillot paper). This photograph shows the rather porous quality of the surface coating (bubbles).

Appian: *Un soir*

Finally, Adolphe Appian's drawing, *Un soir* (cat. 47), is an unusual example of an extinct paper. Described as "grilled" paper in the notes of the art dealer from whom the work was purchased, it is, in fact, Gillot paper, a type of artist's scratchboard.[15] The paper's surface was coated with a soft, clay-based white coating that was then embossed horizontally with a ribbed texture, and over this a series of vertical black lines was printed (fig. 14).

Gillot paper and other textured scratchboards of the late nineteenth century were intended for use by artists in making camera-ready original artwork to be reproduced in publications using photoengraving techniques. Developed in France by Fermin Gillot around 1850, this method, called *gillotage*, was not initially photographic in nature. The original artwork was transferred onto a zinc plate, which was then etched in relief to produce a printing plate that could be printed in the letterpress along with the text. Our drawing is on paper developed by Fermin's son, Charles Gillot, and represents *photo-gillotage*, a refinement to the process. The artist's work on a textured scratchboard was photographed, and the resulting negative was printed onto a photosensitized zinc plate and the plate relief etched. At this time, preparing tonal artwork for a relief printing plate required the artist to find a way to convert line artwork into a form from which a tonal printing block could be made.

Gillot, and other similarly textured scratchboard papers, can be considered an "extinct" paper because it was produced from about 1870 until the 1950s and therefore only available for a limited time in the history of artist's materials.[16] Although some basic forms of scratchboard continue to be available today, these sheets are not textured and do not have the printed patterns. Gillot paper is quite different from its modern counterparts in both use and visual qualities. Textured scratchboard with a printed pattern for use as a drawing substrate for photoetching reproduction, such as that in the Appian example, is no longer available on the market. The extinction of Gillot paper leaves in collections a class of objects that are on a substrate unfamiliar to most students of art history. A deeper knowledge of the context and subtleties of technique used with this type of drawing support allows for a better understanding of and appreciation for the work and the artist's skills.

In part, these new artists' materials were developed as a response to the explosion in illustrated publications that occurred during the latter half of the nineteenth century in Europe and the United States. Sources of textured or "grained" scratchboard (or "scraperboard") in Britain and France were Gillot; in Austria, Angerer and Goeschl; and in the United States, Ross in Philadelphia. The high demand for illustrated publications encouraged the invention of new methods for printing images, and the incorporation of photography into the preparation of printing plates was an obvious time- and labor-saving approach. This led to a variety of techniques that also took advantage of photography's speed and ability to capture fine detail to convert an artist's original artwork into a relief printing plate that allowed the printing of images alongside text in only one pass through the press.

The scratchwork was cut into the surface of the Gillot paper using a knife, sometimes referred to as a *grattoir*.[17] J. Waterhouse described the method of handling the scraping knife to work up highlights on scratchboard (fig. 15):

> It is important to know how to use the scraping knife. The handle is placed between the third and fourth fingers, or between the latter and the little finger, according as it is to scrape in lines or open spaces. The thumb is pressed on the blade, as near the point as possible, in order to overcome its flexibility: the forefinger and middle finger press the instrument against the thumb. The knife should not be passed vertically over the paper, but with the edge forward towards the draughtsman. In this position the knife cuts into the surface like a plane blade. Held any other way, the knife does not clear off the surface completely and soon becomes blunt. [18]

The printed black lines of the Gillot paper would form the middle tone of the composition, and highlights could be scratched into the soft surface with a knife or other tool, revealing the white clay layer underneath (fig. 16). Deeper tones were possible with the judicious use of pencil, black lithographic crayon, or black ink via brush or pen. In his book *A Handbook of Illustration*, A.H. Hinton sets out several aspects of working on Gillot and other types of "scrape boards" (fig. 17).[19] These technologically sophisticated papers enabled the artist to

Fig. 15. Proper position for use of the scraping knife, or *grattoir*, according to Waterhouse. Photograph by author.

Fig. 17. Serrated scraper and four types of textured and printed scraperboards with examples patterns. A. Horsley Hinton, *A Handbook of Illustration* (London, 1984), 96.

Fig. 16. *Un Soir* (detail showing application of pencil and ink media through shadow areas and scratch technique for highlights). Photograph by Rick Hall.

Fig. 18. *Un Soir* (detail of the fisherman). Note how the pencil mark across the back of the figure is broken into a series of dots by the texture of the Gillot paper. It is also clear that the artist went back over the image with black ink after using the *grattoir* for scratching since black ink fills the scratch that defines a highlight across the figure's hip and defines the top of the fisherman's creel. Photograph by Rick Hall.

quickly work up an image for reproduction that, although essentially a line drawing, rendered the image tonally by breaking up the line into a series of fine dots. The printed lines or other pattern on the Gillot paper represented what Hinton called a "full tint." A "half tint" was created by scraping lightly to remove just the printed lines on the tops of the ridges, thereby forming a series of dots. A full white tone was produced by scraping entirely through the ridges to the body of the coating. These tones, combined with pencil drawing and strengthened with black ink, could produce many shades quickly (fig. 18).[20]

In most cases, the artist was working at a larger scale than that intended for the finished publication. According to Hinton: "Reduction causes a very marked improvement, and the drawing should be looked at from time to time whilst in progress with a 'diminishing' glass."[21] Diminishing or "reducing" glasses are still available; they are used for examining advertising copy art when the original artwork will be reduced in the final publication (fig. 19). When making artwork for reproduction at a smaller scale, artists should *not* render details too finely because upon reduction they will block up on the printing plate and not print clearly. Therefore, a certain amount of simplification in detail—and in tonal range—has to be exercised by the artist for a successful printed image. The reducing glass was a tool to enable the artist a "preview" of the drawing in progress so that adjustments to the image could be made accordingly.

Appian's choice of drawing medium—graphite pencil—apart from being a convenient fine-point material, presents certain challenges in the reproduction process. Hinton suggested the grayness of the original drawing may be deceptive: it will reproduce a darker tone than might be expected since the ink used in the final printing is blacker than the graphite. Also, graphite smudges easily, which is of concern because the artist's original drawing had to be turned over to the photoengraver for reproduction and likely passed through many hands along the way. Hinton recommended the use of lithographic crayon for its even, deep black tone and its resistance to smudging.[22]

The reflective quality of the graphite pencil's mark may have been equally troublesome for the photoengraver due to the glare (fig. 20). Glare on the surface of the drawing might reproduce as unwanted, "false" highlights in the finished reproduction, therefore, the lighting of the original artwork would have to be carefully controlled during the photography steps taken by the photoengraver.

Using Gillot paper in the creation of the original artwork allowed for a speedy translation of line work into tonal values that were open enough so that tones on the finished relief printing plate would not block up with ink during printing, resulting in a reduction of clarity of the printed image. In an example of photoengraved illustration, Théophile Steinlen's work was integrated into the design layout for the page as a whole. His use of a shaped support (the arched top perimeter of the drawing shows where the Gillot paper was cut to add another design element to the composition) is characteristic of his work.[24] During the early part of the

Fig. 19. A modern example of a reducing glass.

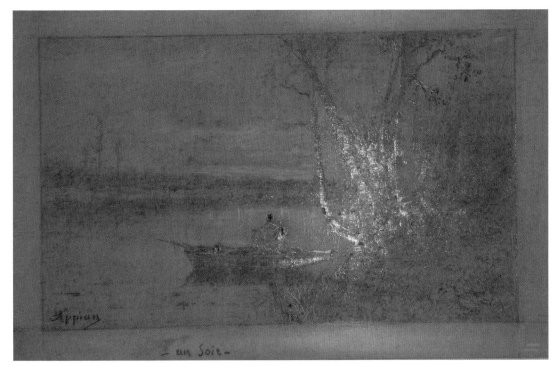

Fig. 20. *Un Soir*. The work is viewed in specular illumination, showing the reflective nature of the graphite, which would prove a challenge to the photo-engraver in reproducing the image for printing.

twentieth century—with the invention of the halftone screen—Gillot paper, and others like it, became obsolete since similar results could be obtained more quickly and with less skill. The artist would not be required to translate his work into a rather difficult medium.

Certain traditional media, though, have great versatility and adaptability.[25] Traditional paper-based printing methods—such as engraving, etching, and lithography—persist and are taken up by a new generation of artists. The Gillot process of photoengraving for illustrating publications did not have this versatility. The papers were highly specialized to serve a specific printing process and were rather expensive to produce. When technology changed, artists moved on to accommodate the new system. The reason for the existence of these specialty papers disappeared and along with it, the papers themselves.

Conclusion

My approach for this study was in part motivated by the remarks of Jim Murrell, a former conservator of portrait miniatures at the Victoria & Albert Museum in London:[26]

> Some years ago I was looking at a collection of paintings with an eminent art historian. There was, in particular, a Reynolds portrait which on close inspection of joins in the canvas and *pentimenti*, could be seen to have been enlarged considerably during its painting so that its subject, instead of leaning against a truncated column, was leading a horse by its bridle. Intrigued, we consulted the sumptuous new catalogue of the collection and were disappointed to find no mention of the alteration. 'As I thought', my companion said disgustedly, 'all done from photographs.' It is an absolute fundamental of connoisseurship that one cannot make judgments about pictures on the evidence of photographs.[27]

This exercise in extended, careful examination highlights the importance of drawings as physical objects. They provide clues within their structure and materials that give us a more complete understanding of artists' purposes and practices as a foundation for further research.

Murrell, in his article, first described the function of close examination of works of art in general, and drawings in particular, as primarily one of connoisseurship (authenticating and attributing works of art). However, the approach is also one that illuminates the artist's intentions in making pictures and the processes by which they were created, subsequently tempering our attitudes toward them. In the digital age, when we are bombarded with facsimile images and simulated experiences, it is good to be reminded of the value of engagement with original objects and their materiality.

NOTES

1. Hammamatsu 1000 Infrared Vidicon Camera. The examination of pictures using infrared light (IR), called infrared reflectography, and a related technique called transmitted infrared photography reveals the relative differences in opacity of different artist's materials to light rays in this portion of the electromagnetic spectrum (wavelengths of roughly 750 to 1400 nanometers). These rays are often capable of penetrating through layers of paint, and the use of this technique in the study of underdrawings on oil paintings is familiar to many students of art history conservators. Infrared examination of drawings on paper can be used to discern the relative opacities of different drawing materials and supports and so helps to identify the content of different artist's materials. It can also be used to reveal drawings hidden under layers of paper that are not visible in normal transmitted light. This technique was most useful in the examination of the Lafage drawing.

2. Max Schweidler, *The Restoration of Engravings, Drawings, Books, and Other Works on Paper*, trans. Roy Perkinson (Los Angeles, 2006). This translation of the 1950 edition of Schweidler's tome on paper restoration describes various techniques used over the years to clean, repair, "improve," and even falsify aspects of prints and drawings, usually to increase their market value. The simple repairs made to this drawing by Lafage in no way compare to the heroic efforts described by Schweidler to make invisible mends or additions to works on paper.

3. Translated notes cited in Antoine Terrasse, *Théodore Rousseau's Universe*, trans. Mary Fitton (Paris, 1976), 49–50.

4. A. Proteaux, *Practical Guide for the Manufacture of Paper and Boards*, trans. Horatio Paine (Philadelphia, 1866), 26.

5. Ibid., 31.

6. Proteaux, 28.

7. Irene Brückle, "The Historical Manufacture of Blue Paper," *The Paper Conservator* 17 (1993): 20–31. This article includes an extensive discussion of the traditional methods used to make blue and other colored papers. The durability of the indigo dye stems in part from its ability to withstand the pH extremes created when the rags were macerated, retted (alkaline conditions), or fermented (acidic conditions) in preparation for stamping to break down and hydrate the fibers prior to sheet formation.

8. Brückle, 23.

9. Proteaux, 88.

10. The British Museum has in its collection a drawing by Juan de Ribalta, *Miraculous Healing of a Saint*, from the seventeenth century, made of pen and brown ink with red-brown wash on red paper. Inventory number 1846.0509.174.

11. In addition to rose-colored paper, Rousseau is known to have created landscape drawings on yellow paper, apparently mimicking the bright, warm tone of full sunshine. Interestingly, microscopic examination of our drawing reveals a fair number of stray yellow paper fibers scattered across the surface. It may be that these are residue from other drawings that the artist stored along with this rose-colored work. Certainly, paper fibers migrate from one sheet to another when stacked, especially on paper such as this kind, which is only moderately sized and therefore has a somewhat soft surface.

12. The author is grateful to Rick Hall, photographer at The Blanton Museum of Art, for his work on the color sampling. His readings from a digital image of the drawing are as follows: The pink color on the right edge of the original has an overall color reading of: R – 171, G – 118, B – 115, K – 47%; The overall color reading of a faded area adjacent to the pink is: R – 187, G – 158, B – 131, K – 35%.

13. X-ray fluorescence elemental analysis (XRF) reveals that the paint contains the element mercury, which suggests that the pigment is most probably mercuric sulfide (HgS), also known as the pigment vermilion.

14. Karl Buchberg, "Seurat: Materials and Techniques" in Jodi Hauptman, *Georges Seurat: The Drawings* (New York, 2007), 31–41. The essay by Mr. Buchberg, a conservator at The Museum of Modern Art, gives a detailed description of a unique work in Seurat's oeuvre, a drawing on Gillot paper, obviously intended for publication. What is interesting is that no other drawings by this artist on Gillot paper survive. How many others may have been produced and then not considered worthy of collecting because they were working drawings in service to the production of a printed image (the "final product"), notwithstanding the fact that they were in fact finished works in themselves?

15. The latest reference to the production of this type of paper I have found was for scratchboard products of the Charles J. Ross Co. of Philadelphia in the *Ninth Graphic Arts Production Yearbook* (New York, 1950), 114.

16. Phillip Dennis Cate, *Prints Abound: Paris in the 1890s* (Washington, DC, and London, 2000), 16. See also Phillip Dennis Cate and Peter A. Wick, "Printing in France, 1850–1900: The Artist and New Technologies," *Gazette of the Grolier Club*, n.s. nos. 28–29 (June–December 1978): 57–82.

17. Kimberley Schenck, "Crayon, Paper and Paint: An Examination of Nineteenth-Century Drawing Materials," in *The Essence of Line: French Drawings from Ingres to Degas* (University Park, PA, 2005), 63.

18. J. Waterhouse, *Practical Notes on the Preparation of Drawings for Photographic Reproduction* (London, 1890), 111. Waterhouse, in his comments about drawings in charcoal and their reproduction, remarks that Appian was an acknowledged master of this medium as well as graphite pencil: "Of late years, especially in France, charcoal of 'fusain'

151

drawing has taken a very high place among the graphic arts. Charcoal drawings are very well adapted for multiplication by photography, as testified by the beautiful reproduction of drawings of this class by Allongé, Appian, Lalanne and other masters of this art, to be found in the print shops in Paris," 104.

19. A. Horsley Hinton, *A Handbook of Illustration* (London, 1984).

20. Ibid., 96–97.

21. Ibid., 101.

22. Ibid., 100.

23. For an example of Steinlen's original work in a shaped support of Gillot paper, see Schenk, 63, fig. 5.

24. Peter Bower, "The Evolution and Development of 'Drawing Papers' and the Effect of this Development on Watercolor Artists, 1750–1850," *The Oxford Papers: Proceedings of the British Association of Paper Historians Fourth Annual Conference*, 1996. Bower points out that from the earliest introduction of papermaking to Europe, papers intended for the sole purpose of artist's use in drawing did not really exist. Artists of the time selected from the paper types available on the market, and these were primarily for one of three intended uses: writing, wrapping, or printing. Only in the late eighteenth and into the nineteenth centuries was there a significant effort on the part of papermakers to create papers specifically for use by artists. This occurred for several reasons; the primary reason, however, may have been the greatly increased demand by amateurs for artists' materials during this period. Bower points out that, in fact, many traditional types of paper have great versatility for artists use and so enjoyed a longevity in the history of paper manufacture. The converse of this is that many of the modern specialty artists' papers have quite limited uses and so appear only for a finite time in paper history. Gillot paper is an example of the latter.

25. J. Murrell, "Observations on Holbein's Portrait Drawings," *Paper Conservator* 20 (1996): 1–7.

26. Ibid., 1.

27. Ibid., 1.

REFERENCES

AFA 196
American Federation of Arts with R. Wunder. *17th & 18th Century European Drawings.* New York, 1966.

AFA 1967
American Federation of Arts with A. Hyatt Mayor. *15th & 16th Century European Drawings.* New York, 1967.

AFA 2003
American Federation of Arts with Alastair Laing. *The Drawings of François Boucher.* New York, 2003.

BMA 1999
The Jack S. Blanton Museum of Art. *Old Master Drawings from the Suida-Manning Collection.* Austin, 1999.

BMA 2006
The Jack S. Blanton Museum of Art. *The Handbook of the Collection.* Austin, 2006.

Bordeaux 1984
Jean-Luc Bordeaux. *François Le Moyne and His Generation, 1688–1737.* Neuilly-sur-Seine, 1984.

Bober 2001
Jonathan Bober. *I grandi disegni italiani del Blanton Museum of Art dell'Università del Texas.* Milan, 2001.

Brejon de Lavregnée
Arnauld Brejon de Lavergnée. *Nouveau tableaux de chevalet de Michel Dorginy.* Paris, 1992.

Briquet
C. M. Briquet. *Les Filigranes: Dictionnaire historique des marques du papier dès leur apparition vers 1282 jusqu'en 1600.* 4 volumes. New York, 1985.

Churchill
W. A. Churchill. *Watermarks in Paper in Holland, England, France, etc., in the XVII and XVIII Centuries and Their Interconnection.* Nieuwkoop, 1990.

Clark 1998
Mastery & Elegance: Two Centuries of French Drawings from the Collection of Jeffrey E. Horvitz. Cambridge, 1998.

Cremona 2001
Museo Civica, Cremona. *Capolavori della Suida-Manning Collection.* Milan, 2001.

Dayton 1962
Robert L. and Bertina Manning. *Genoese Masters: Cambiaso to Magnasco, 1550–1750.* Dayton, 1962.

Heawood
Edward Heawood. *Watermarks: Mainly of the 17th and 18th Centuries.* Hilversum (Holland), 1986.

Jacoby 1986
Beverly Schreiber Jacoby. *François Boucher's Early Development as a Draughtsman, 1720–1734.* New York, 1986.

Lefrançois 1994
Thierry Lefrançois. *Charles Coypel: Pentre du roi (1694–1752).* Paris, 1994.

Lugt
Frits Lugt. *Les Marques de Collections de dessins & d'estampes* and *Supplément.* San Francisco, 1975.

MMA 1986
Metropolitan Museum of Art. *François Boucher, 1703–1770.* New York, 1986.

Matthiesen 1987
François Boucher: His Circle and Influence. New York, 1987.

McCauley 1985
Anne McCauley. *Nineteenth-Century French Caricatures and Comic Illustrations from the University of Texas Collections.* Austin, 1985.

McGrath 1997
Elizabeth McGrath, *Rubens, Subjects from History*, Part 13, Volume 2, London, 1997.

Michel 1906
André Michel. *François Boucher.* Paris, 1906.

Munhall 2002
Edgar Munhall. *Greuze the Draftsman.* New York, 2002.

NGA 1973
National Gallery of Art with Regina Shoolman Slatkin. *François Boucher in North American Collections: 100 Drawings.* Washington, DC, 1973.

New York 1964
Robert L. and Bertina Manning. *Genoese Painters: Cambiaso to Magnasco, 1550–1750.* New York, 1964.

New York 1996
Carmen Bambach and Nadine Orenstein. *Drawings and Prints, 1530–1800.* New York, 1996.

Ontario 1972
Art Gallery of Ontario with Pierre Rosenberg. *French Master Drawings of the 17th & 18th Centuries in North American Collections.* New York, 1972.

Raux 2007
Sophie Raux. "Le voyage de Fragonard et Bergeret en Flandre et Hollande durant l'été 1773." *Revue de l'art* 2, no. 156 (June 2007): 11–28.

San Antonio 1995
San Antonio Museum of Art. *Five Hundred Years of French Art.* San Antonio, 1995.

Schnapper 1974
Antoine Schnapper. *Jean Jouvenet 1644–1717, et la peinture d'histoire à Paris.* Paris, 1974.

INDEX

Page numbers in *italics* refer to illustrations.

COLLECTORS AND SOURCES LISTED IN PROVENANCE

Lenora W. Blackburn
b. Midland, Texas, 21 August 1904;
d. 13 April 1993

Willis C. Blackburn
b. Union Grove, Wisconsin, 5 April 1903;
d. Mobile, Alabama, 15 September 1967

Philippe de Chennevières
b. Falaise, Calvados, 23 July 1820;
d. Bellême, Orne, 1 April 1899

David & Constance Yates Fine Art, New York

Clarence Dillon
b. San Antonio, Texas, 27 September 1882;
d. Far Hills, New Jersey, 14 April 1979

Hector Giacomelli
b. Paris, 1 April 1822;
d. Menton, 1 December 1904

Christian Humann
b. Paris, 6 July 1929;
d. May 1981

Michael Ingram
b. 1917;
d. South Cerney, Gloucestershire, England, 2005

Joel R. Bergquist Fine Art, Stanford, California

Bertina Suida Manning
b. Vienna, 5 December 1922;
d. Queens, New York, 6 October 1992

Robert Lee Manning
b. Mart, Texas, 19 May 1924;
d. Queens, New York, 17 April 1996

P. & D. Colnaghi and Co., London

The Prince de Ligne
b. Brussels, 23 May 1735;
d. Vienna, 13 December 1814

The Princes of Liechtenstein

Alvin Romansky
b. Houston, Texas, 15 March 1907;
d. Houston, 14 March 1994

Ethel Romansky
b. 25 September 1917;
d. 15 January 1986

Spencer A. Samuels & Co., Ltd., New York

Johan Conrad Spengler
b. Copenhagen, 22 July 1767;
d. Copenhagen, 1 March 1839

N.G. Stogdon, New York

William E. Suida
b. Neunkirchen, Austria, 26 April 1877;
d. New York, New York, 29 October 1959

Latané Temple
b. Houston, Texas, 12 December 1914;
d. San Miguel de Allende, Mexico, 9 September 1997

Julius H. Weitzner
b. New York, New York, in 1896;
d. London, United Kingdom, 14 January 1986